# Discovering
# ALABAMA
# FORESTS

The University of Alabama Press    Tuscaloosa

# Discovering

# ALABAMA FORESTS

DOUG PHILLIPS

PHOTOGRAPHS BY ROBERT P. FALLS SR.

FOREWORD BY RHETT JOHNSON

Designer: Michele Myatt Quinn
Typeface: Granjon

Printed in Korea by Pacifica Communications

∞

The paper on which this book is printed meets the minimum
requirements of American National Standard for Information
Sciences-Permanence of Paper for Printed Library Materials,
ANSI Z39.48-1984.

Library of Congress Cataloging-in-Publication Data

Phillips, Douglas Jay.
  Discovering Alabama forests / Doug Phillips; photographs
by Robert P. Falls, Sr.; foreword by Rhett Johnson.
      p.    cm.
  Includes bibliographical references (p.    ) and index.
  ISBN-13: 978-0-8173-1525-2 (cloth: alk. paper)
  ISBN-10: 0-8173-1525-X (alk. paper)
1. Forests and forestry—Alabama—History. I. Title.
  SD144.A2P55 2006
  333.75'09761—dc22                    2006000842

Publication of *Discovering Alabama Forests* is made possible in
part through the generous support from the following:
The Solon and Martha Dixon Foundation
The William Reynolds Ireland Sr. Endowed Support Fund

The authors would like to thank our good friend
Linda Reynolds for her invaluable assistance.

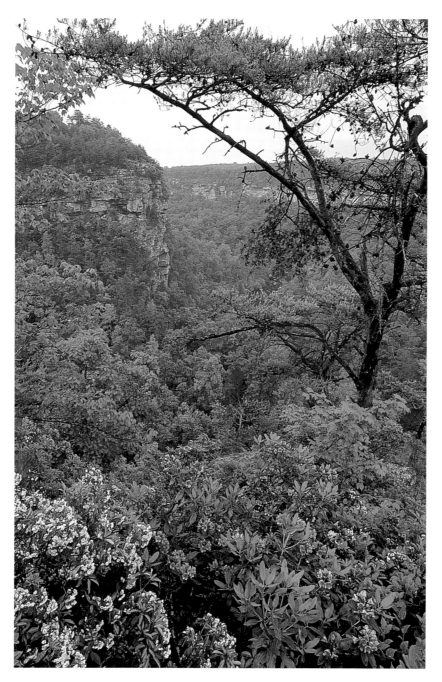

Spring in Little River Canyon, blooming mountain laurel *(Kalmia latifolia)* and rhododendron *(Rhododendron catawbiense)*.

# CONTENTS

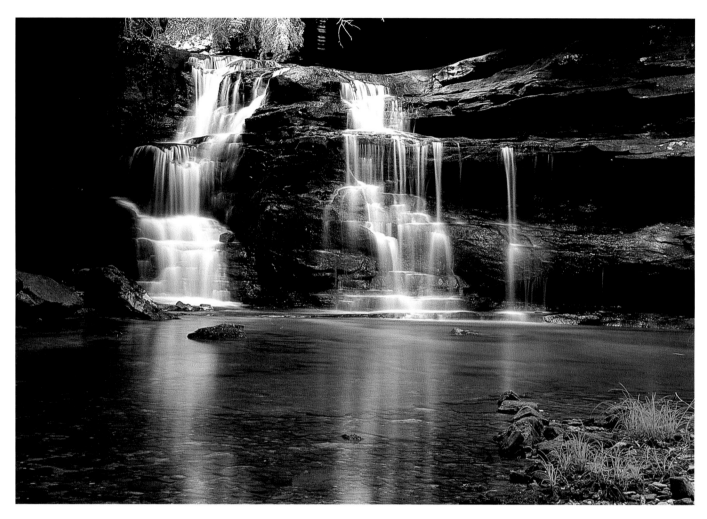

Cascade in spring, one of many unspoiled forest-shrouded wonders in the Sipsey Wilderness Area.

# FOREWORD

THE STORY OF ALABAMA'S FORESTS IS IN many ways the story of Alabama and of the Southeast. It is the story of Alabama's past, from prehistory through settlement, its modern eras of development and exploitation, and its promising future.

Alabama's forests are wonderfully diverse, with a broad range of tree species across a wide spectrum of land types. The photographs in this book capture a great deal of that diversity beautifully, but they can only capture a moment in time, a snapshot. The life of forests is long, with many changes taking place along the way. Any description of a forest—oral, written, or visual—is accurate only for the period of time in which an observation or image is made. The forest you see today, even without human intervention, will be far different a mere ten months from now, to say nothing of ten years hence. Forests are dynamic living organisms, ever-changing tapestries, with one community replacing another as time passes. Ecologists call this "succession," and it proceeds until a forest reaches its landscape-dictated "climax" condition. Here in the Deep South, even that state tends not to last. Disturbance events are

a part of our lives here. We have grown accustomed to, if not accepting of, wildfires, hurricanes, tornadoes, pine beetles, floods, and droughts, and so have our forests. That may be the most singular strength of Alabama's forests. They are amazingly resilient, withstanding the ravages of man and nature. They have generally persevered through repeated assaults from Mother Nature, saws and axes, and even the plow. Only the laying of blacktop and pavement seems to give them pause.

*Discovering Alabama Forests* describes this long journey from the forests of prehistory to today. Author Doug Phillips has adroitly avoided placing blame, recognizing instead the social and economic forces that have acted over time to shape the forests of today. The story is sometimes a familiar one of a seemingly endless resource whose very abundance made it a barrier and hindrance to human ambition. Later generations recognized the enormous economic potential of this forest resource but lacked the science and foresight to utilize it in a sustainable way. Wholesale harvests of Alabama's rich forests resulted in a landscape ripe for big agricul-

ture. But, again, ignorance led to the depletion of far too much of Alabama's soil, which was then often forsaken. Slowly the forest reclaimed those lands, although it was a changed forest, significantly different from the one settlers first found here. Chestnuts were gone, as was most of the longleaf pine. Opportunistic species like loblolly pine and sweetgum, natives both, quickly occupied old fields and cutover forestland. Human suppression of fire, a natural influence that shapes much of the world's forest systems, effectively removed this variable from the land. Aggregations or communities of forest plants and animals waxed and waned, depending on seral or successional stage, soil moisture regimes, forest age, sunlight, shade, and other factors. Species became established, prospered, declined, and disappeared. As the science of forestry advanced, though, Alabama's inhabitants learned to shape the forest to best fit their needs. The "natural" forest existed only as scattered remnants of itself, although the best examples were— and are—spectacular. From wetlands to dry sandy ridges, Alabama still contains representatives of all of its original forests.

Today a new generation of landowners and managers looks to the forest for more than what they can extract from it. Foresters, wildlife biologists, ecologists, and others are learning to see the forest in its entirety, as more than the sum of its parts. A new lexicon has emerged to reflect this change. Words like *restoration, sustainability,* and *ecosystem integrity* have become commonplace in boardrooms, seminars, workshops, and classrooms. Some of us are uncertain whether we are guiding our society into a new era of forest stewardship or if we are being led by a populace demanding a new paradigm.

As encouraging as this turn is for the fate of Alabama's forests, there is still much to be done. Even today, many view our forests as undervalued and underutilized real estate or just take them for granted. Others see our forests as museums, to be preserved or protected. The answer lies somewhere in between. Our forests are still vital to our economy *and* to our quality of life, and we can have them both ways.

*Discovering Alabama Forests* uses the past as prologue, fostering an appreciation of what we have now and might have in the future, and what the loss of our forests would mean for us all. It is a powerful testament to the legacy of our landscape. So glory in these wonderful photographs, learn from the rich history of our forests and the perils they face, and go out and experience them—in all of their majesty—for yourselves.

RHETT JOHNSON

# PREFACE

## Whispering Pines

A RESTAURANT STAFF MEMBER IN VANCOUVER, Canada, once inquired, upon learning where my spouse and I live, if people in Alabama actually eat tomato sandwiches. It seemed incomprehensible to her. After confirming this fact I invited her to visit our state, where some of the tastiest tomatoes are grown and where perhaps she would better understand.

In the summers of my youth in Alabama, lunch typically consisted of a tomato sandwich on white bread and a frosty glass of sweetened iced tea, which I enjoyed while leaning against the trunk of a longleaf pine tree in the yard of my home. During those steamy, hot, endless days, before air-conditioning was prevalent in our society, the tree was a place of respite, a sanctuary where daydreams were born, the only place a nap was possible.

For those yet to experience such a treat, yes, the breeze does—in fact—whisper through the needles of such a tree. Indeed it absolutely sings when the breeze increases to a wind of exuberance, a phenomenon sorely underappreciated these days. In times gone by the term *whispering pines* was found all over Alabama, naming motels, restaurants, even shopping centers. But even the terminology is disappearing as it loses significance with every new generation.

Alabama has a wide variety of other types of trees, but to my mind the story of Alabama's forests is the story of the southern pine. Much has been written on the subject, in both fact and fable, and it occupies a place of mysticism in the hearts of southern fiction writers. The southern pine touches our lives in ways too numerous to mention here.

Vast forests of immense longleaf pine once covered the landscape of Alabama, but now they are in severe decline. Why should we care? One need only examine the state champion tree (as of this writing) located in Butler County to understand. I stand before it awed, in silence or speaking in hushed tones. The tree is immense—113 feet in height, 122 inches in circumference, with a crown spread of 55 feet. Not comparable to the towering redwoods of California by any means, but surely such trees deserve the same protection. I am encouraged that some organizations are now working toward that end.

Regardless of how badly we humans abuse our envi-

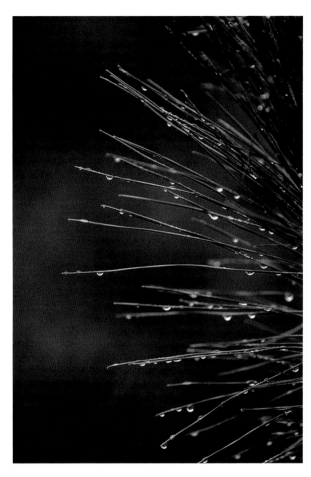

Needles of longleaf pine *(Pinus polustris)* in fall rain, Oak Mountain State Park.

ronment, the wind will continue to serenade us as long as the abundant needles of the southern pines are in existence. Pine trees will always be a part of the property where I live, even though life is much different for me today: I spend a great deal of time behind a camera and far more time than I wish in front of a computer. Cooking has become a pastime that I enjoy tremendously, and friends are nice enough to say that I do it well—even when I experiment on them! Favorite recipes come and go, but the tomato sandwich, now on nine grain bread, with artificially sweetened iced tea, remains a staple of my summer diet, and an integral part of that includes sitting under the loblolly pine trees at my rural Blount County home. Two of these trees now shade a gazebo, with "easy chairs" installed, where I can enjoy the music of the pines, a place where my grandchildren can visit and share a tomato sandwich, and listen to something not found on their CD players or GameBoys.

There is an old axiom that says "you can take the boy out of the country, but you cannot take the country out of the man." There appears to be a modicum of truth in that, at least on my part. Suffice it to say I find that living in Alabama is good, and a large part of that can be attributed to the whispering pines that I love. Sometimes the simpler things in life are the best.

ROBERT P. FALLS SR.

# Discovering
# ALABAMA
# FORESTS

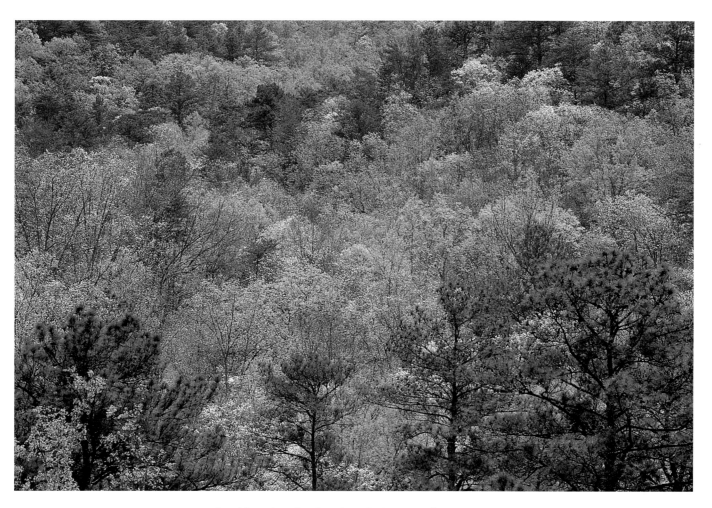

Mixed forest, springtime in Talladega National Forest.

# INTRODUCTION

### Behold This Verdant Land

Newcomers to Alabama always marvel at the natural beauty of the state. Invariably they respond with surprise upon finding that "everything is so green!"

Vibrant, green forests dress more than 22 million acres of the Alabama landscape, roughly two-thirds of the state. Only Oregon and Georgia have a comparable abundance of forested acreage. Moreover, Alabama's forests are far more diverse than those in any other region of the United States. With almost two hundred kinds of native trees, Alabama has more than twice the tree species of all of New England. Native oaks alone number around forty species, nearly double the number of oak species found in the Appalachian forests from Pennsylvania to North Carolina.

The many oaks are but one facet of the state's great number of hardwoods, which include multiple species of trees and shrubs often considered emblematic of other regions. For example, Alabama has seven species of maple, eleven species of holly, and five of elm. The state is also home to five species of buckeye, while the official buckeye state, Ohio, has only two.

Likewise, among hardwoods popularly associated with the South, Alabama has several kinds that occur in multiple species. The varieties of dogwoods and magnolias, for instance, total roughly a dozen species, most thriving in wild settings shared with scores of less celebrated hardwoods, including sourwood, sycamore, tuliptree, hickory, beech, birch, blackgum, sweetgum, basswood, cottonwood, ash, and willow.

The impressive array of Alabama hardwoods are found in an equally impressive variety of habitats throughout the state. Yet the green landscapes that command newcomers' attention are just as likely to be draped with softwoods, or conifers. Alabama conifers include species of juniper, hemlock, cypress, and pine—especially pine. The state has eight distinctive pines: shortleaf, longleaf, loblolly, slash pine, Virginia pine, spruce pine, sand pine, and pond pine.

These different species have each claimed their pre-

Spring mosaic, Bankhead National Forest.

Sugar maple (*Acer saccharum*), fall scene, Blount County.

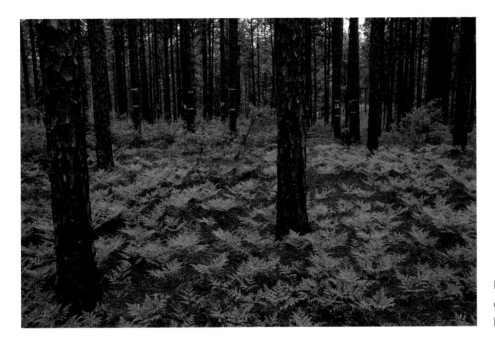

Regrowth of bracken fern (*Pteridium aquilinum*) after fire, pine stand, Talladega National Forest.

ferred soils and settings, with the ubiquitous loblolly distributed most widely across the state. However, it is the longleaf pine that enjoys the honor of being Alabama's official state tree. This classic southern yellow pine, uniquely resistant to fire, insects, and disease, is known historically for its prized lumber. Once among the most abundant species in the state, the longleaf today continues to recover from early decades of overharvesting. Recent attempts to reestablish longleaf forests in Alabama are inspired by our reawakening to the ecological significance of native forest systems.

New scientific recognition of Alabama's forests is timely, as many forests elsewhere in the world are being substantially diminished. This is the reality in underdeveloped areas where forests are cleared and wood is depleted to meet basic needs for survival. Such is also the case in successful industrialized regions where forestlands are converted to make room for expanding urban development. And extensive forest decimation is often the result when logging companies from industrialized nations invade tropical rain forests of underdeveloped countries.

In almost every instance, excessive forest exploitation is driven by the rising demands of a growing human population. Such exploitation brings troublesome consequences for vulnerable species of plants and animals

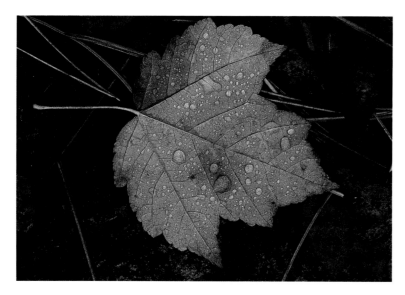

Morning moisture on leaf of red maple (*Acer rubrum*), fall.

and for the forest communities to which they belong. Eventually, excessive damage to native ecosystems spells environmental degradation that poses problems for local economies and, ultimately, for the health and well-being of human populations.

Alabama, with its abundant forest resources, enjoys a special opportunity to achieve harmony between the economy and the environment. As science uncovers more about the marvels of forest ecology, we can better manage forest resources to avoid mistakes of the past and maintain the environmental health of Alabama forests. As other regions reveal the dilemmas of depleted forests, we can take heed and better plan to sustain the economic productivity of Alabama forests.

Fortunately Alabama has already started down the road toward forest sustainability. Numerous agencies and organizations in the state are deeply committed to perpetuating the multiple values of Alabama forestlands. In many respects, Alabama forests are in better condition today than they have been for the past one hundred years.

Meanwhile, Alabama in the years ahead can expect accelerating population growth and related change similar to that occurring in many parts of the South. With this will come new and changing demands on our forests. The dedication of various forest-related agencies and organizations will succeed only if joined by a public spirit of appreciation for Alabama's forest heritage—for the history of the state's forest, for the many forest values and benefits, and for the importance of our forests to the future quality of life for generations to come. *Discovering Alabama Forests* is a labor of love intended to promote this spirit of appreciation by celebrating Alabama's remarkable forest wonders.

Autumn mosaic, Oak Mountain State Park.

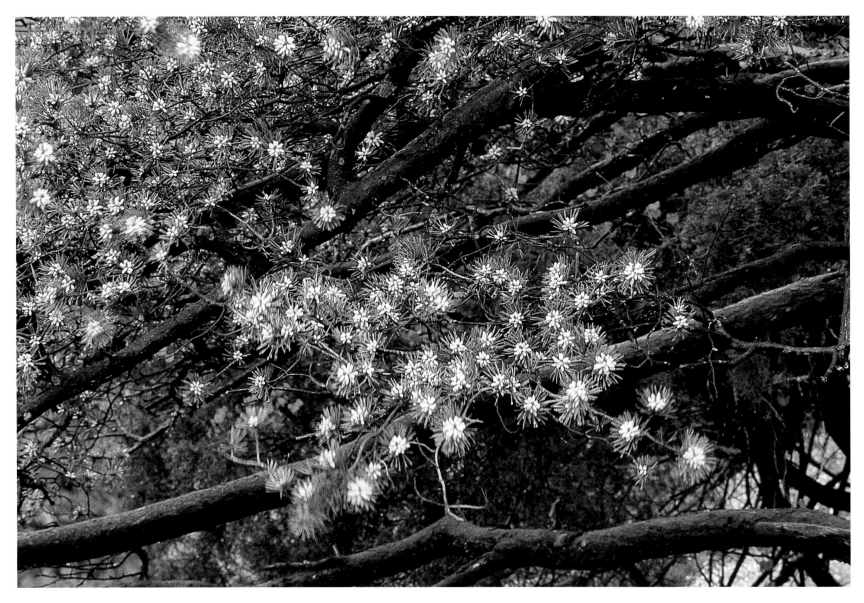

Shortleaf pine *(Pinus echinata)* with pollen-bearing cones, springtime.

# FOREST HISTORY

*We did not think of the great open plains, the beautiful rolling hills, and the winding streams with tangled growth as wild. Only to the white man was nature a "wilderness." . . . To us it was tame. Earth was bountiful and we were surrounded with the blessings of the Great Mystery.* —Luther Standing Bear

MOST OF US, AT ONE TIME OR ANOTHER have wondered what Alabama's forests were like before the region was settled, before the arrival of the ax, the saw, and the machinery of forest exploitation. An accurate understanding of this forest history requires that we look back across time to early periods of the Earth's history.

## ORIGINS

Eons of geological events have shaped and reshaped global landscapes, giving rise to plants, animals, and a world of profound biological richness. The history of our forests reflects this story of time, change, and the progression of life.

*Emergence*

Alabama's forests represent the culmination of plant development underway since primeval periods. Scientists generally agree that the first forms of chlorophyll-containing life were blue-green algae populating the watery realms of a young Earth whose atmosphere was laden with carbon dioxide. Gradually new plant life developed with the capacity for producing strong cellular tissues, root systems, and vascular walls, thus enabling adaptation to land.

The origin of today's forests can be traced to early varieties of vascular plants, such as primitive spore-bearing types that established along marshy shores during the Silurian and Devonian periods of geologic time. Fossil remnants of Alabama's first tree-sized plants can

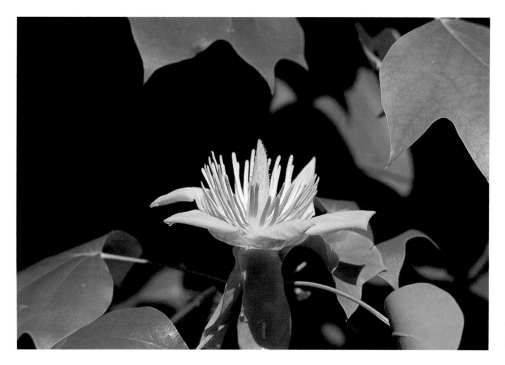

Tuliptree *(Liriodendron tulipifera)* in spring bloom, Cherokee County.

be found in the state's oldest geological region, the Piedmont, among the 400 million-year-old sediments called the Erin Shale.

Many of the earliest green plants contributed to a major atmospheric transformation as they metabolized volumes of carbon dioxide, storing the carbon and releasing the oxygen, and helping advance life on Earth. By the Pennsylvanian period, protoforests of giant horsetail and fernlike plants were prevalent around large swamps where early animals progressed from living in the water to living on land. Some of the best fossil evidence of this age, known as the Carboniferous period, is seen in the extensive deposits of Alabama's coal measures, dating to 320 million years ago.

Subsequent geological periods gave rise to varieties of seed-bearing plants (gymnosperms) able to populate drier, upland settings. These plants typically bore their seeds on the scales of cones, thus the common name for this group, *conifers*. Fossils of the earliest forms of conifers, for example, the palmlike cycads, indicate that such species spread during the Triassic and Jurassic periods, when the Alabama climate was very dry, perhaps desertlike in places. The continuing development of conifers in later periods would eventually produce forest communities such as the native pine forests found today among Alabama's pine hills.

# GEOLOGIC TIMELINE
## Tracing Development of Plants and Other Life Forms

Precambrian Time
From Earth's formation until about 600 million years ago; earliest life (non-nucleated, bacteria-like); first algal
forms of plant life; first multicelled animals followed by development of early communities of complex animals

| Era | Period | Epoch | Years Ago | Record of Plants and Animals |
|---|---|---|---|---|
| Paleozoic | Cambrian | | 570 million | first appearance of major groups of animals |
| | Ordovician | | | first fish; proliferation of invertebrates |
| | Silurian | | | first land plants and animals |
| | Devonian | | | first land vertebrates; proliferation of fishes |
| | Mississippian | | | proliferation of amphibians; proto-forests of carboniferous age |
| | Pennsylvanian | | | development of reptiles; extension of proto-forests of carboniferous age |
| | Permian | | 245 million | abrupt changes to plant & animal forms and extinction of much of Paleozoic life |
| Mesozoic | Triassic | | | rapid development of reptiles & mammals; first dinosaurs; development of coniferous plants |
| | Jurassic | | | proliferation of dinosaurs; first birds |
| | Cretaceous | | | development of flowering plants; abrupt changes to Mesozoic life, including extinction of dinosaurs |
| Cenozoic | Tertiary | Paleocene<br>Eocene<br>Oligocene<br>Miocene<br>Pliocene | 65 million<br>55 million<br>34 million<br>24 million<br>5 million | rapid development of birds and mammals<br>appearance of grazing mammals, spread of open grasslands<br>development of primates<br>development of many modern families of mammals and trees<br>development of first hominids in Africa |
| | Quaternary | Pleistocene<br>(ice age) | 1.8 million | fluctuation and continued development of modern animals and plants; Man spreads out of Africa |
| | | Holocene<br>(recent) | 10 thousand | Man inhabits North America, including southeast; present-day biota is established |

"Grass" stage of growth, longleaf pine, Talladega National Forest.

However, long before the arrival of the variety of tree species we see today, a next, dramatic development of plant life occurred. By the late Cretaceous period, around 90 million years ago, the Alabama climate was in the midst of an extended tropical phase. Fossil evidence from this time reveals the spread of a whole new group of plants, flowering and fruit-bearing plants (angiosperms), able to thrive in many kinds of settings and habitats. The continuing development of these plants would eventually produce the first broad-leaved, deciduous tree species in the state and give rise to rich hardwood forests such as those now prevalent along Alabama's Appalachian foothills and expansive river bottoms.

While flowering species were spreading to become the dominant plants on Earth, mammals began their ascendance to become the dominant animals. In fact, this period of plant progression is linked with a key advance in the animal world. Anthropologists tell us that the availability of fruit-bearing plants provided a ready source of nutrition supporting the rise of a new kind of mammal, primates.

Over the last 50 million years, various forms of primates used plants, trees, and forests in meeting basic needs for survival. By the Miocene epoch, about 20 million years ago, most of today's families of mammals had appeared, and Alabama had gained a major portion of the tree families we see today, although individual species and communities of species would continue to change (as they still do today). Evidence from this age indicates the presence in Alabama of early forms of oaks, hickories, elms, and hollies, as well as cypress and pines. This was due, in part, to a gradual global cooling that pushed the more tropical plants southward, leaving Alabama ideally situated for a diversity of wide-ranging deciduous species.

The cooling temperatures that occurred in the Miocene and in the following epoch, the Pliocene, were mild compared to the big chill of the next epoch, the Pleistocene, known as the "ice age." Beginning about 2 million years ago, the Pleistocene actually wrought a series of ice-age events, as huge sheets of glacial ice alternately advanced and retreated over much of North America. These icy protrusions never reached further south than the Ohio Valley, but this was close enough to have major effects on climate, river levels, landforms, and plant and animal life in Alabama. Fossil evidence from this age reveals a region in fluctuation. At times the Alabama landscape was extensively populated by northern evergreen species, such as hemlock and spruce, migrating south ahead of the glacial ice. At other times, these cold-adapted species had receded, giving way to an increase of hardwoods, with a mix of species from both warmer and colder environs. Roaming these forests were such ice age creatures as huge mastodons and mammoths—animals that still thrived here during the last glacial retreat, around 15,000 years ago.

By the end of the Pleistocene, primitive *Homo sapiens* cultures had migrated from Africa to many parts of the world, including North America, which by this time had acquired most of the land features seen today. Prevailing theory holds that these earliest peoples came across the Bering Strait and wandered gradually down the continent. Along the way, they passed by sparsely

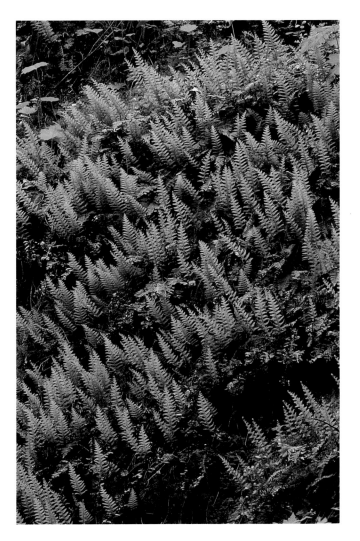

A moist forest microenvironment harboring a patch of Christmas ferns *(Polystichum acrostichoides)*.

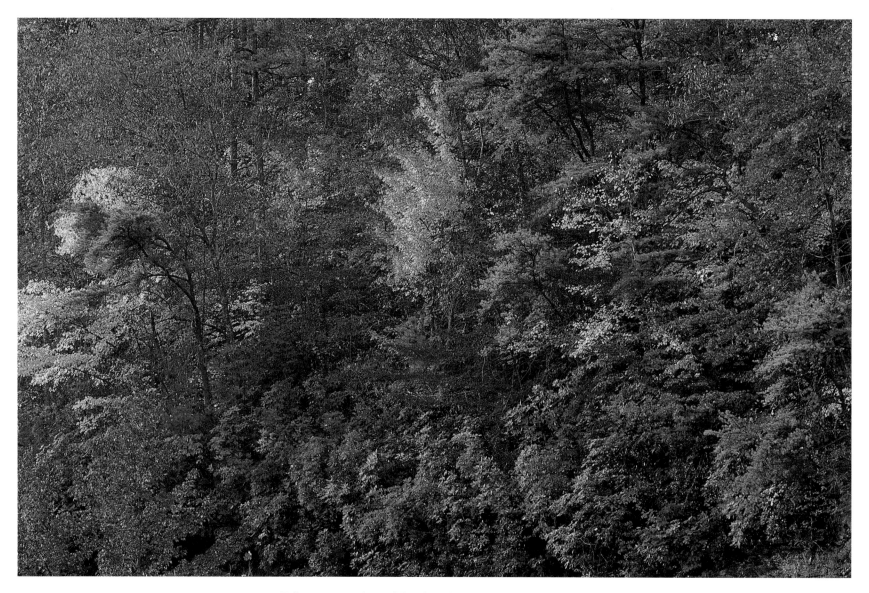

Fall canyon colors, Little River Canyon Nature Preserve.

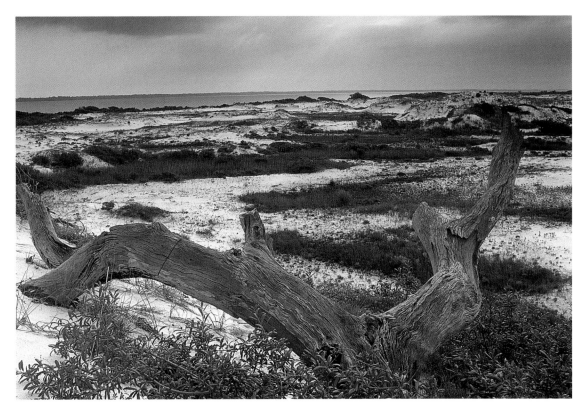

Weathering wood
of fallen tree,
Alabama coast.

forested regions of subarctic vegetation, through cold-climate zones of coniferous forest, over treeless stretches of desert and grasslands, and on to the edge of the temperate South, where nature was underway with one of her grandest performances, the magnificent woodlands of the southern forest.

## Discovery

Nomadic tribes of hunters and gatherers pushed into the Southeast about 12,000 years ago, whereupon they encountered the land of Alabama, with its special topography, suitable soils, and countless streams and rivers, all uniquely arrayed in forest diversity. No doubt these earliest inhabitants were the first newcomers to gaze in awe and wonder at Alabama's rich green landscape.

The physiography of this landscape was generally the same as we know it today. The topography-forming effects of the ice age were over, establishing the Alabama coastline pretty much as it presently lies and leaving

Insect tracks inside bark of pine tree. Invasive insects such as the infamous pine bark beetle can cause forest devastation if not controlled.

the lower half of the state, the Coastal Plain region, with its present mixture of rolling hills and prairie lands interspersed with wide valleys and broad floodplains. Likewise, the northern, Appalachian region of the state stood dressed in the same rugged appeal we find today, a mountainous vestige of geological events from long before the ice age.

Alabama forests, on the other hand, continued to change and adapt in response to such vagaries of nature as shifting weather patterns, storms, and periods of damaging insects and disease. Therefore, it is difficult

to accurately track the changing conditions of Alabama's forests across the millennia since the ice age. We know the kinds of trees that were present, but we cannot be sure of the size, age, and ecological status of the forests as they changed from time to time and from region to region in response to natural causes.

Of course, another factor affecting forest conditions over the past 10,000–12,000 years has been the human presence. As prehistoric cultures progressed from hunting and gathering to farming, so, too, their lifeways shifted from foraging in the forest to clearing it. The

best evidence indicates that fire was a primary tool for this. Deliberate and frequent burning was employed to create open areas for villages and for agriculture, and to establish herb- and grass-rich fields attractive to wildlife such as deer and turkey. Again, it is difficult to fully gauge the extent to which these practices affected Alabama's forestlands. We know from early accounts that these Indian practices were extensively evident on the Alabama landscape at the time of European exploration, but we cannot be sure of the full scope of such human activities in the centuries prior to this.

European exploration into Alabama is, perhaps, most famously associated with the excursions of Hernando de Soto around the mid-1500s. At the time, Alabama forestlands were exclusively the domain of Indians skilled in using, and wise in knowing, the forest. These native Americans were initially inclined to share the bounty of the woodlands with the European newcomers. However, such generosity would soon turn to hostility as the red man realized that the white man had little regard for the native peoples and little fondness for the native forests. The ensuing cultural conflict is reported among the pages of de Soto's *Chronicles,* which includes sketchy references to various landscapes of Alabama. For example, one account revels in the fact that a certain tract of forest contained such large trees as to create an open, parklike setting enabling de Soto's horsemen to gallop at full speed in pursuit of fleeing Indians. Elsewhere, however, the *Chronicles* make men-

River birch *(Betula nigra)* in spring, Tuscaloosa County.

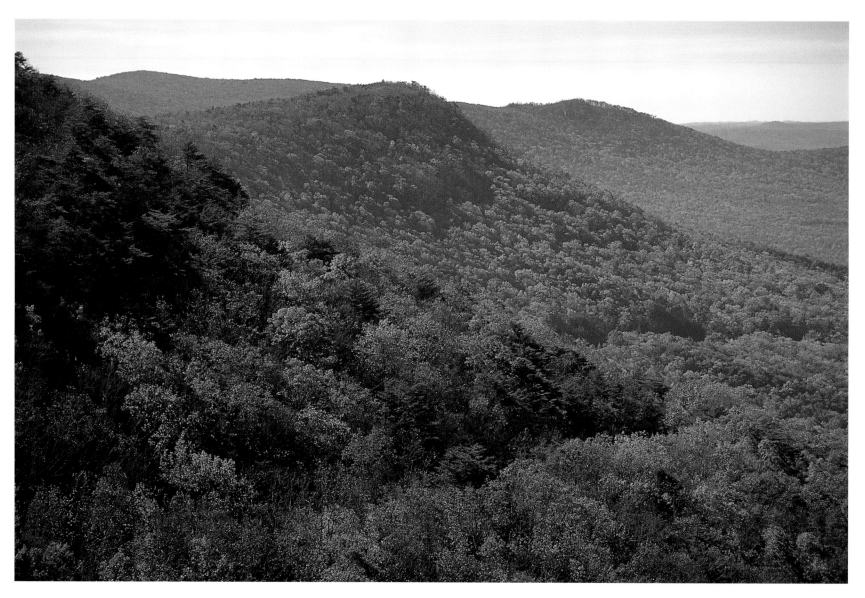

Southern terminus of Appalachia, Talladega National Forest.

tion of other settings—plains, savannas, canebrakes, fields, and brushy growth—lacking in significant forest cover. These fragmentary descriptions provide an intriguing glimpse of the region's apparently mosaic features. However, we are still left to wonder what Alabama's forests were actually like before the sting of the settlers' saws.

Following the Spanish came the French and the British, each trekking through aged Alabama woodlands that stood at the time of the nation's birth and that were present soon thereafter to witness the settlement of our state. This forest realm, the first of historical record, is therefore often considered Alabama's "original forest." Some sources proclaim that the original Alabama forest was so ancient and expansive that a squirrel could travel from Georgia to Mississippi without ever touching the ground. Others counter this notion of a vast old-growth forest, contending instead that Alabama was yet a mosaic of different settings. The truth, it seems, includes aspects of both scenarios.

Alabama's original forest was, in many respects, a regenerated forest. Native peoples had long since been decimated by diseases introduced with the Europeans' arrival. Many of the lands that the natives had kept thinned and cleared were therefore left to revert again to forests.

Into this largely regenerated sylvan realm ventured British naturalist William Bartram in 1773. A trained botanist, Bartram was one of the first to scientifically examine the southern forest. His survey across much of the Southeast, highlighted in the famous publication *The Travels of William Bartram,* includes observations confirming a variety of impressive lands found in Alabama.

For example, Bartram did indeed find old-growth forests:

Opposite this bluff, on the other side of the river, is a swamp or low land, the richest I ever saw, or perhaps anywhere to be seen: as for the trees, I shall forbear to describe them, because it would appear incredible: [they] are by far the tallest, straightest, and in every way the most enormous I have seen or heard of.

As Bartram meandered across central and south Alabama, he found areas with "grand high forests . . . of larger growth" than anything he had seen before. In places, these were hardwood forests, with trees sometimes greater than ten feet in diameter. In other places, they were pine forests, including endless stands of "great long-leaved pine." Also, Bartram did indeed find a variety of nonforested landscapes:

and the plains present to view a delightful varied landscape consisting of extensive grassy fields, detached groups of high forest trees, and clumps of lower trees, evergreen shrubs and herbage; green knolls with serpentine wavy glittering brooks cours-

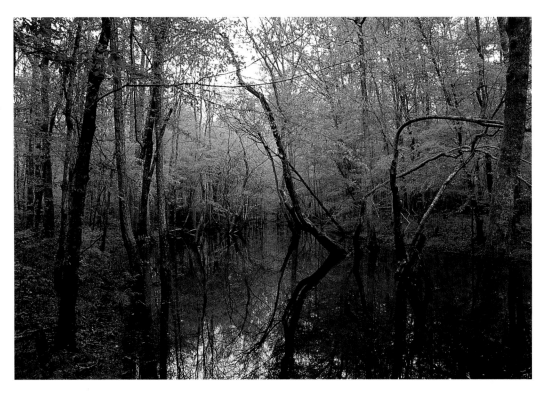

Tupelo gum *(Nyssa aquatica)* and river birch in an elbow pond near a small river in Tuscaloosa County.

ing through the green plain, and dark promontories . . . alternately advancing or receding on the verge of illumined native fields, to the utmost extent of sight.

Another prominent feature Bartram found was prolific cane. In lowlands and along river bottoms, wide cane-brake areas sometimes stretched for miles.

William Bartram's observations confirm an early Alabama of varied landscapes. However, his descriptions of Alabama's grand forests were especially significant during this period of budding romanticism inspired by the wilds of native America. The poetry of such notable romanticists as Samuel Coleridge and William Wordsworth reveal the influence of Bartram's embrace of Alabama forests. For instance, Wordsworth's vision of a "magnolia spread / High as a cloud, high overhead" is apparently drawn from Bartram's stop at a splendid magnolia site in northern Baldwin County. Other poetic descriptions reflective of Bartram's Alabama visit allude to forests of such sublime appeal as to stoke the imaginations of pioneers and settlers soon to arrive.

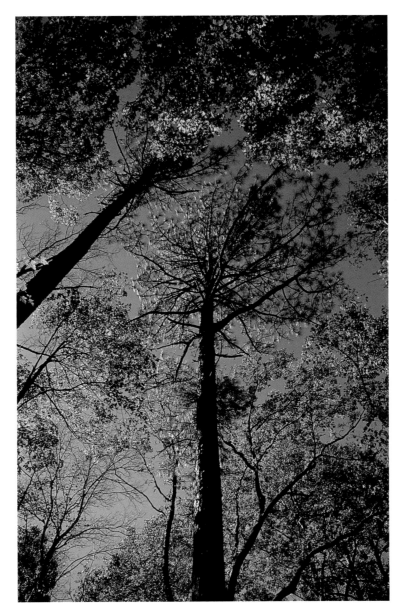

Towering loblolly pines *(Pinus taeda)*, Talladega National Forest.

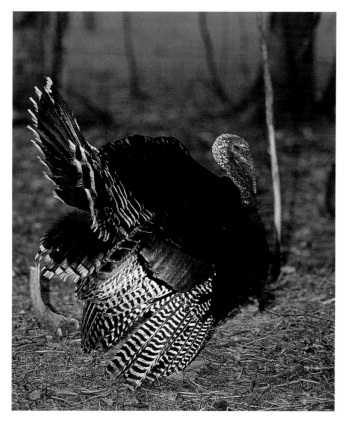

The male wild turkey *(Melagris gallopavo)* displays tail feathers to attract females, south Alabama woodlands.

## STATE SETTLEMENT AND EARLY DEVELOPMENT

The period from early settlement to early industrial expansion in the state is sometimes portrayed by history books as a story of hardy pioneers, intriguing military personalities, and the advance of machinery and technology to serve human progress. However, this period is also largely a story of native people and forests encountered, native people and forests destroyed.

The preface to the story had occurred centuries earlier when several of the first European adventurers came ashore along Alabama's Gulf beaches. Across these wild coastlands they walked among pristine stands of maritime forests, including ancient specimens of both conifer and hardwood species adapted to the salty, windy coastal environs. In time, Mobile Bay became a welcoming gateway to the New World as excursions of the presettlement period followed the rivers extending inland from the bay. The broad floodplains of these rivers awed newcomers with great tracts of river bottom hardwoods, including huge cypress and tupelo in the swampy areas and giant oaks, hickories, ash, and other species in the better-drained areas.

Any trip overland in this region soon led to vast stretches of towering longleaf pines, the dominant forest type over much of the lower part of Alabama. Another remarkable forest resident, occurring from south Alabama up through most of the eastern United States was the American chestnut tree. Alabama woodlands were home to chestnut trees of venerable age and size.

As commerce developed along the river ways, trade routes also reached across the northern part of Alabama, into the Tennessee Valley and over the highlands of the Cumberland Plateau and Appalachian chain. Here, too, were abundant river bottom forests, together with great tracts of upland hardwoods and pines.

Early settlers in the Alabama region found the forests still home to the Indians, who were banded in the historical tribes of the Choctaw, Chickasaw, Creek, Cherokee, and Seminole. Each tribe claimed a different part of Alabama, and each felt strong attachment to the forest and the animals therein. Raccoon, beaver, deer, and turkey inhabited woodlands throughout the region. Here, also, bison, bear, and cougar still roamed. The fabled trumpeting of the ivory-billed woodpecker still penetrated the deep recesses of ancient cypress forests. The happy banter of the red-cockaded woodpecker still punctuated the wind song of the towering longleaf forests.

By the early 1800s, these rich woodlands, so majestic to William Bartram and so beloved by the Indians, were increasingly seen by outsiders as timberlands for the taking. In fact, the lure of Alabama's forests contributed to a phenomenon called "Alabama fever," whereby the heralded resources of the state drew waves of settlers into the region to take advantage of "land and timber aplenty."

In 1814 the Creek Indians made their last stand against the white man's incursions, at the famous Battle of Horseshoe Bend. The Cherokee and other Indians were rounded up under orders of the 1832 Indian Removal Act, and the infamous Trail of Tears took them brutally westward, leaving Alabama forestlands wholly to the preferences of white settlers.

Subsequent impacts to the forest began innocently

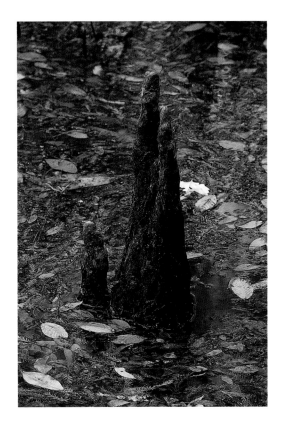

Root, or "knee," of a baldcypress (Taxodium distichum) in a wetland adjoining the Cahaba River.

enough. Trees were felled for building cabins, pens to hold livestock and, conversely, pens to keep free-roaming livestock from intruding on crops, yards, and gardens. Perhaps most rapaciously, wood was used for heating and cooking. More than half the wood cut from the forest was used for energy. An average household might burn as much as forty or fifty cords in a year, consuming upwards of sixty tons of wood annually.

Pioneer cabin, circa 1800. Wood is still considered the best building material.

Fence-building was another major use. Historians calculate that around this time in United States history there were 3 million miles of wood fencing, much of it aging and rotting at a rate that required 64,000 miles of replacement each year.

The uses of wood during the early 1800s included ways the modern world has long since forgotten. There were wooden plates, wooden nails, and wooden dams. Some communities even constructed wooden roads of layered planks.

*Depletion*

By the mid-1800s, many Alabama woodlands were converted for a different purpose; entire sections of land were cleared for growing cotton. Now the state's population of white residents was matched in number by a black population, serving as slave labor for southern plantation owners. A growing number of people and an expanding area of cleared land combined to take a new toll on Alabama's forestlands.

The plantation system faded with the end of the Civil War, but this five-year conflict itself took a further toll on Alabama forests. Iron was needed to supply the cannon, ammunition, and other needs of war, and the fledgling iron industry was dependent upon wood to fuel the smelting process. Such an operation required a steady supply of wood. For example, the Confederate iron-making furnaces located just south of Birmingham (at today's Tannehill Ironworks Historical State Park) caused the forests to be stripped bare for miles around.

Another major impact from the Civil War was frequent forest fire. All across the region, woods were burned, sometimes by accident from the explosions and heat of battle, but many times fires were set deliberately as a tactical strategy of the war. The smoke frequently portrayed in renderings of the period was often heavy across the forestland, as well as on the battlefield.

During the 1800s improving saw technology made it easier to cut even more timber. In pioneer days the task of cutting trees and squaring timbers with an ax was

The sycamore *(Platanus occidentalis)* has bark that varies in colors of white, green, gray, and brown.

slow and difficult. Timbermen often developed great physical endurance and exceptional skills as they swung their axes from daylight until dark, "from kin 'til kant." An early method of sawing logs into timbers and planks was also physically difficult. Called "pit sawing," it required men to pull a log gradually through the length of a constructed trough while other men stood on a platform built around this "pit," manually pulling a saw blade back and forth into the face of the log.

Eventually many communities adapted waterpower to operate saws in a fashion similar to that used to power their gristmills. This was followed by steam power, and the word *mill* began to take on a whole new dimension. Large timber mills with circular saws replaced small operations and increased by volumes the consumption of Alabama woodlands.

A number of Alabama's early communities grew in connection with these mills, which were generally located near streams so that logs could be floated to the mill site. Typically the mill owners paid independent loggers to do the work of supplying logs for milling. Most of the logging was done along the streams because the only method available for skidding logs was via brute force, usually with teams of oxen, sometimes with horses or mules.

Of course, rafting logs by way of Alabama's creeks

and rivers was fraught with constant challenge. At times there was frustrating drought. Other times, there was dangerous flooding. And then there were the day-to-day dealings with insects and snakes, not to mention the arduous and dangerous work of log rafting itself.

The crosscut saw was introduced after the Civil War, enabling faster, easier cutting. This, too, helped to increase the amount of timber harvested, although the pace was yet governed by the tedium of hand labor. Meanwhile, many Alabama woodlands were put to other productive uses before they were cut. The practice of "turpentining" involved hacking the bark off of pines to collect pine rosin, which was then heated to yield turpentine. The stores of concentrated rosin, or "tar," were also popular for sealing the seams of wooden ships— thus the early American term *naval stores*.

The business of "turpentining" provided a livelihood for many Alabamians, but it was also very destructive to the forest. Fortunately the industrial age would find materials other than pine rosin for sealing seams, and while turpentine today remains a common by-product of commercial forestry, it is produced by methods that do not damage forest resources.

For most of the 1800s, the felling of Alabama forests continued at a rate dictated by the physical limitations of man and animal. So the coming of the industrial age found Alabama and other parts of the Deep South still with large areas of old-growth woodlands. Many such areas contained tracts of Alabama's original forest and

represented the last sizeable stands of untouched, virgin forests remaining in the region. This would soon change forever during a period of the most relentless forest exploitation in American history.

Armed with the doctrine of Manifest Destiny, Americans were marching west to claim new territories of land aplenty. Only, many of these lands were sparsely forested. Timber for crafting tools, building towns, and most other needs was in short supply and in big demand. Among the most ravenous of demands was that of the smoking iron horse and its requisite railroad tracks. Not only did the early locomotives burn wood, but the freight cars, bridges, and train stations were made of wood. And, of course, the rail tracks were laid atop wooden cross ties, at an average of five miles of cross ties per mile of rail. Like wooden fences, ties also required replacement every few years. According to official estimates, by 1900 the need for railroad ties alone had resulted in the cutting of more than 20 million acres of forests.

During the latter half of the 1800s, most of the prime timber of the North was exhausted. Timbermen began looking to the South and to Alabama. By now, new practices were needed to speed up the logging process. The slower oxen teams were replaced by steam-powered "skidders," which dragged larger clusters of logs out of the forests to be piled beside railroad tracks and then quickly loaded onto freight cars by machine loaders. Thus began the infamous era of "cut-out and

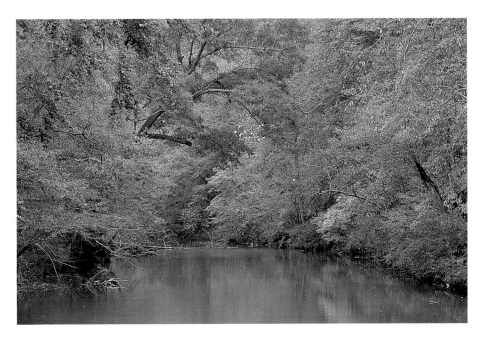

Riparian forest along stream in Blount County.

Sourwood tree (*Oxydendrum arboreum*) in red fall color. Its flowers attract bees and are the source of highly prized sourwood honey.

Carolina buckthorn *(Rhamnus caroliniana)*, commonly called Indian cherry.

get-out." Railroads pushed into all parts of the South, at the behest of a new breed of woodland intruder, the railroad lumbermen, who stripped large portions of southern forests hurriedly and abusively. This careless overcutting was compounded by the expanding conversion of forestlands to pasturelands and row crop agriculture. Between 1880 and 1920, forest cover in many parts of the South had been reduced by 80 percent.

The forest impacts that occurred during this period left many landscapes largely denuded, soils badly eroded, and streams heavily silted. With natural habitats fragmented and destroyed, wildlife populations were decimated. This sad moment for Alabama marked the culmination of a fifty-year span of similarly unchecked exploitation across America, a period of natural resource devastation that became known as the "age of extermination."

## Recovery

The American ideal of freedom remained in its adolescence for much of the nineteenth century. Whereas the Revolutionary War had won Americans their right to freedom, the Civil War engaged an American struggle to clarify the meaning of freedom. Through this conflict the nation achieved necessary gains on the human front, only to face the mounting consequences of yet unchecked freedoms on the environmental front.

In Alabama, insult was added to widespread forest

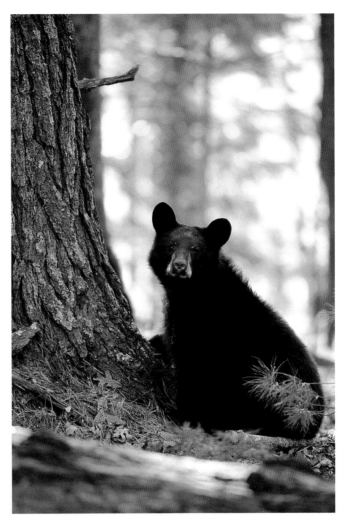

Beech tree (Fagus grandifolia) in fall. This species is easily identified in winter because it usually retains most of its leaves, which turn from autumn yellow to a soft brown color before giving way to the new green growth of spring.

The black bear (Ursus americanus), once inhabiting all parts of the state, is today found only in extreme southern Alabama in forested wild areas such as along the Mobile-Tensaw river delta.

Carolina silverbell *(Halesia carolina)* in spring. The shedding white blooms have prompted the common name "snow-drop-tree."

injury by the fact that there was no systematic inventory of the botanical resources of the state. Alabama's first formally appointed state geologist, Eugene Allen Smith, had collected numerous botanical specimens in the 1860s and '70s, during his famous horse-drawn wagon expeditions to various parts of Alabama. The work of expanding this study fell to botanist Charles Mohr, who inherited Smith's collections in 1879 and undertook to catalog the plants of Alabama. In his subsequent report, *Plant Life of Alabama,* Mohr makes special note that, in regard to floral classification, "Alabama . . . remained until the last quarter of the eighteenth century a terra incognito." Following Mohr, a new lineage of scientists would undertake the study of Alabama's native flora and fauna—and none too soon, as native species in many parts of Alabama were beginning to suffer ecological harm from an unexpected threat, that of invasive plants and diseases often introduced as a consequence of widening patterns of trade and commerce. A most notable example is the infamous disease "chestnut blight," which by the mid-1900s had completely eradicated the American chestnut from Alabama forests.

Unfortunately the forest exploitation of the late 1800s was already underway at the time of Mohr's important work. His findings across Alabama include such descriptions as "this forest . . . is entirely destroyed, and presents a picture of ruin and utter desolation painful to behold." The Great Depression that began in the 1920s

is usually described as an economic crisis, but it was also a manifestation of a crisis of the human spirit, related in part to devastated landscapes, depleted forests, eroding soils, and vanishing wildlife.

However, the wanton abuse of America's natural heritage was already the subject of many eloquent voices—artists, authors, and naturalists—who recognized that, once again, America was due for a reassessment of the idea of freedom. The previously unrestrained American freedom to exploit natural resources must now be checked by fostering a national sense of responsibility for protecting these resources.

Among the first American leaders to champion this new responsibility was U.S. President Theodore Roosevelt. TR joined with sportsmen's groups such as the American Hunting Riflemen, and with preservationist groups such as the Sierra Club to work for protection of America's declining natural heritage. At first there were campaigns for parkland preserves, as in the celebrated case of Yellowstone National Park. Soon to follow were efforts for wildlife restoration, for establishment of the National Wildlife Refuge System, and for forest protection, including expansion of a federal system of forest reserves.

Meanwhile the era of exploitative lumbermen was giving way to the emerging field of professional forestry. The science of forest management was spearheaded by such authorities as Gifford Pinchot, the first U.S. chief of forestry, and Henry Hardtner, the South's

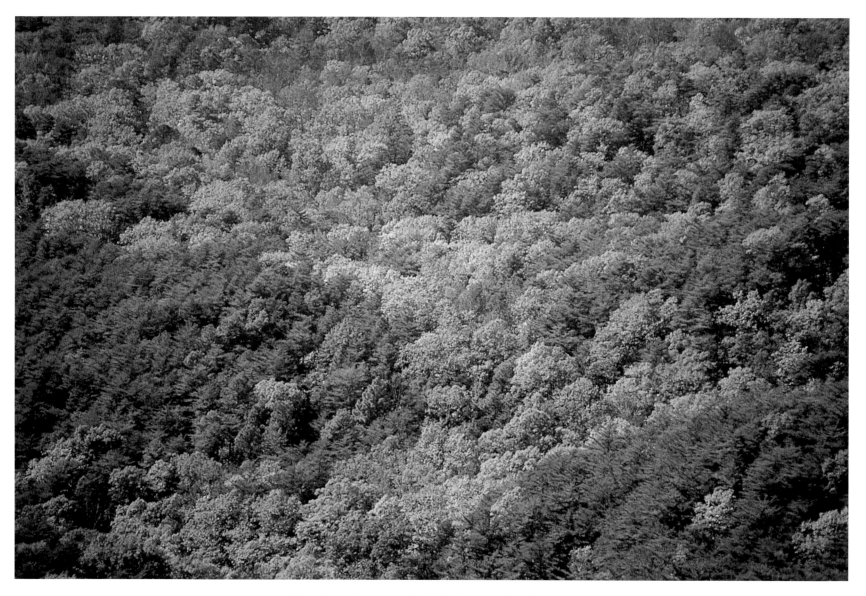

Mixed forest community, Talladega National Forest.

A sassafras *(Sassafras albidum)* sprouts through a dead leaf.

own "father of forestry" and the first to promote forestry studies as a standard college offering.

These proponents of conservation were influential in spawning a new perspective of forest management that involved protection from fire, changes in cutting practices, and applied methods of forest regeneration. By as early as 1900, a number of Alabama landowners and lumbermen began to convert to this new approach. However, the real revolution in forest recovery would come later, with help from another Roosevelt, President Franklin Roosevelt. FDR's national revitalization program, the New Deal, was the impetus behind numerous expanded initiatives for conservation, including the Civilian Conservation Corps (CCC). By the 1930s, the federal system of forest reserves had been transformed into the National Forest System. Government forestlands and parklands in Alabama, as in other states, became major CCC working grounds for reforestation efforts. Divisions of CCC men and women labored long days planting trees one at a time by hand to help restore many thousands of acres of Alabama forest. The same was done for many private lands, as new forestry agencies, soil conservation agencies, and other governmental programs were created to assist in promoting conservation of natural resources. Around this time, newly established land-grant colleges were founding schools of forestry and subsequent experimental stations for forest research.

The Society of American Foresters provided oomph to the growing field of professional forestry, influencing government, corporate, and individual landowners to consider better practices of forest management. These various facets of conservation activity in the 1930s and '40s are often lauded as being the nation's original environmental movement.

Perhaps ironically, the advance of forest management was also aided by continuing improvements in the technology and economics of forest utilization. Develop-

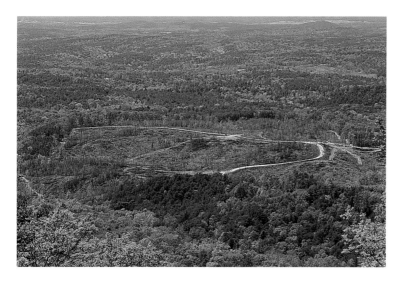

Clear-cut opening in Talladega National Forest. Federal guidelines for national forests require that most such timber harvests be relatively small in size.

ment of the chain saw enabled quicker, less laborious tree cutting. Rubber-tired machinery made for easier skidding, loading, and hauling of logs. A mushrooming variety of wood products meant new markets and the opportunity for new profits from timberlands. Alabama forests were now beginning to enjoy greater appreciation as an economic resource of high value, to be managed and sustained rather than wastefully exploited.

Forest management was making progress at a timely moment, as World War II brought another demand for wood, to meet many critical needs of the armed forces. Once again Alabama forests supplied a wide range of items, from decking and crating to medicines and ammunition. Meanwhile, a new resident was taking root, so to speak, on the Alabama landscape—the pulp and paper industry. By the 1950s and '60s, the state's

general economy was benefiting from the rapid growth of this industry, which raised to new levels the harvest of Alabama's forests but also took care to restore tree growth on abandoned fields and pastures, and to replant and reforest cutover areas. Additionally, pulp and paper companies provided a welcome market for a variety of forest products previously considered of low value, further boosting economic incentives for sustaining important forestland resources. However, the spread of commercial forestry also gave broad public visibility to two pursuits that seemed counterintuitive to careful forest management. These were the scientifically ordained practice of clear-cutting and the conversion of natural forests to commercial pine plantations, activities that not only provoked derision from some segments of the public, but often elicited criticism from the

The early tones of spring usually appear in the last weeks of winter.

ranks of forestry professionals themselves. Alabama's recovering forest, like the original forest before it, was being dramatically affected by the escalating demands of a growing, developing society.

Enter the national environmental movement of the 1970s. Heightened public concern for the nation's lands, waters, and forests prompted a rash of new environmental laws, several of which resulted in further guidelines for forest management. Over the last several decades, increasing environmental awareness and ever-improving commercial technology have helped shape the regeneration of another Alabama forest.

Just as the history of Alabama's forest serves to inform the present, so this informed purview lends perspective on the past, helping to interpret the unchanging fact of continuous forest change. In that sense,

today's forest is considered the latest phase in a generalized sequence from period to period across time. Alabama's "first forest" is considered the forest encountered by the settlers and used to meet the escalating need for wood through early industrial development, until it was largely depleted by the voracious lumber boom begun in the late 1800s. Alabama's "second forest" comprises the subsequent decades of forest recovery, sprouting from the innate productivity of Alabama lands with assistance from new national concern for forest conservation. Alabama's "third forest" is considered the latest general phase of statewide regrowth, begun in the 1950s and '60s following establishment of the pulp and paper industry in the state and expansion of commercial forest management. Much of the timber supplying raw materials for Alabama today is still cut from this third forest.

Sweetgum leaves in a forest stream.

An acorn sprouts a root in search of soil.

National Scenic Byway, spring, Talladega National Forest.

# ALABAMA'S FORESTS TODAY

*You can't get lost in the woods if you're at home in the woods.* —anonymous woodsman

ALABAMA'S FORESTS ARE ONCE AGAIN lush and bountiful, despite a checkered history of human use and abuse. And today, after several decades of harvesting timber from this, the state's third forest, Alabama is now well into the production and use of yet another generation of forest growth, its "fourth forest," expected to carry the state through the early part of the twenty-first century.

Forestry professionals have monitored Alabama's changing forests since the 1950s, issuing periodic public reports on the status of forest conditions. Among the more recent reports are, for example, the Fourth Forest Study, coordinated by the Alabama Forest Resources Center, and the Alabama Forest Inventory for the year 2000, conducted jointly by the U.S. Forest Service and the Alabama Forestry Commission. These assessments conclude that, over the past forty years, Alabama's forest acreage has continued to regenerate, growing stock has increased, and timber volumes, both for hardwoods and pines, have more than doubled. All the while, the total of forestland in Alabama has remained between 22 million and 23 million acres.

Meanwhile the modern age continues to bring new and sometimes accelerating changes to Alabama forestlands. For example, ever-improving technologies have contributed to faster tree growth and shorter harvest cycles, with the result that many lands, particularly those under industry ownership, are already producing trees representative of fifth, sixth, and even seventh forest generations. As a result, in localized areas of the state, annual harvest rates have exceeded annual growth rates.

Tempting the opossum, a persimmon tree *(Diospyros virginiana)* displays its fruit, Oak Mountain State Park.

Such commercially driven practices generate a spectrum of attitudes and reactions among different interest groups, often provoking angry controversy and fueling political conflict over a host of forest issues (discussed further in chapter 3). However, the many natural wonders of Alabama's forests abide beyond the rancor of human dispute.

## FOREST DIVERSITY

Alabama lies mostly within the southern deciduous forest zone of the eastern U.S., with lower parts of the state extending into the coniferous forest zone of the gulf coastal region. These two zones, products of unique geological events together with a temperate climate, are especially rich in plant diversity and afford exceptional innate capacity for forest growth and regeneration. As a result, Alabama's forests today still reflect the native diversity of the state's original forest conditions. The essential components of this forest diversity are, of course, the trees.

### Tree Variety

Few places on Earth are as blessed with so wondrous an array of tree species as is Alabama. Most official tallies place the number of species at around two hundred and, as noted in the introduction, include a greater variety of such species as oaks, maples, and magnolias than occur elsewhere in the United States.

The precise count of Alabama tree species can differ, depending upon the source. This discrepancy is due to several variables, not the least of which is whether a

given species is native or naturalized. Native species are those established historically and considered indigenous to the natural forest. Naturalized species, on the other hand, are those that have been introduced from other regions but have adapted over time to reproduce and coexist within the wild. Listings of Alabama trees are available from a variety of sources, including the popular *Guide and Key to Alabama Trees*, a handy, quick reference guidebook to most native trees and several of the common naturalized species.

Another area of discrepancy affecting the enumeration of tree species has to do with the simple question, What is a tree? Experts are unanimous that, essentially, a tree is a perennial plant with an erect woody stem and a crown of woody branches. However, it seems there is less agreement about requisite physical dimensions. An early guideline required that trees develop trunks at least three inches in diameter and grow to heights of at least sixteen feet. Today scientific opinion is more flexible, allowing consideration for a broader range of woody plants, including such smaller species as witch hazel, wax myrtle, and poison sumac, plants that previously have often been relegated to the separate category of shrubs. When shrubs are included in the count of Alabama's trees, the total number doubles to more than four hundred species. (A list of Alabama forest shrubs can be obtained from the USDA Forest Service, Southern Research Station, with offices at Auburn University.)

The question of requisite tree dimensions has little bearing on the unquestioned reality of Alabama's remarkable abundance and diversity of trees. In fact, trees are themselves a grand wonder of nature.

Trees are not only composed of wood, the world's best building material, but they are also living, breathing, reproducing organisms—they are *alive*. Indeed, trees are the largest living creatures on Earth. Some tree species, the giant redwoods, for example, grow to almost three hundred feet in height and weigh more than the largest whales in the sea. In Alabama, such species as the oaks, tuliptree, sycamore, baldcypress, and pines can also reach far greater proportions than other life forms in the state.

Trees are also among the longest living creatures on Earth. The life span of the bristlecone pine, a western mountain species, can exceed four thousand years. In Alabama, the baldcypress can live to around one thousand years, and a number of other species, including live oak, tuliptree, and longleaf pine, can live beyond five hundred years. Of course, such longevity is commonly curtailed by natural causes—insects, disease, decay, lightning, and storm damage. But the normal life span of many Alabama trees can reach well past one hundred years if not shortened by the needs and pursuits of man.

Trees are all the more amazing in their design and function. For most Alabama trees the root of their wonderful design is actually an intricate system of several kinds of roots. Central to this system is the taproot,

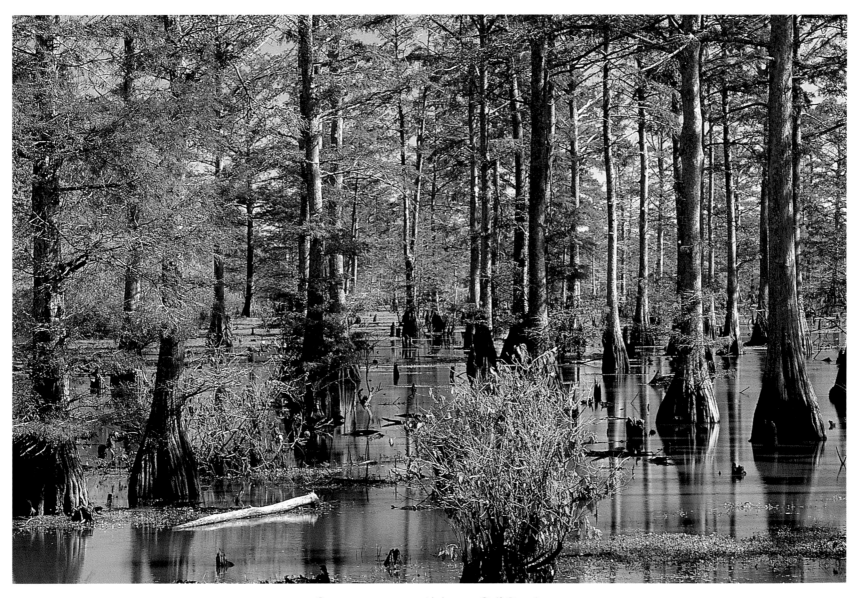

Cypress swamp on Alabama Gulf Coast.

reaching deeply downward from the base of the trunk to seek water. The taproot is joined by a number of additional vertical roots in providing mainstay anchorage to the earth.

As the tree grows, it develops a complex pattern of horizontal roots, called lateral roots, that reach far away from the trunk. These in turn produce vast networks of very fine roots whose chief function is to pervade the topsoil and take up nutrients. This is aided by the symbiotic association of tree roots with nonpathogenic fungi that produce nutrient-absorbing structures called mycorrhizae. Many of the puffballs and mushrooms found in the forest are the fruiting bodies of mycorrhizae.

The tree trunk is another example of advantageous engineering. This is due in large part to the unique cellular construction of wood, which pound for pound is stronger than steel yet light enough and flexible enough to support its own weight and withstand most effects of wind. Add to this a layered anatomy including heartwood, sapwood, cambium, and bark, and the tree trunk is both a mechanical and biological wonder at assisting nutrient transport, water uptake, waste disposal, and other processes of life.

A tree's tenaciousness for vertical growth is itself quite a phenomenon. The tip of the tree's trunk detects the direction of gravity and reacts to counter gravity's pull. This is particularly evident in those cases when a tree has been bent or held down by another tree that has fallen across it. Suppressed trees typically exhibit curious

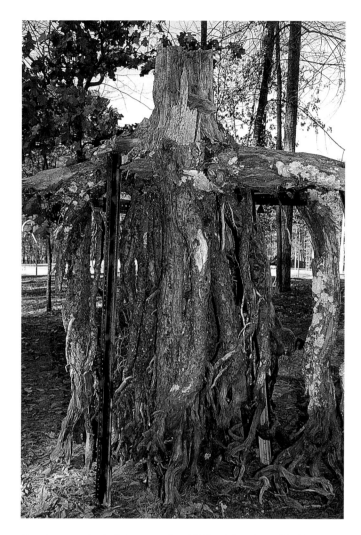

Roots revealed. A tree root exhibit at Guntersville State Park shows primary vertical roots on an extracted stump.

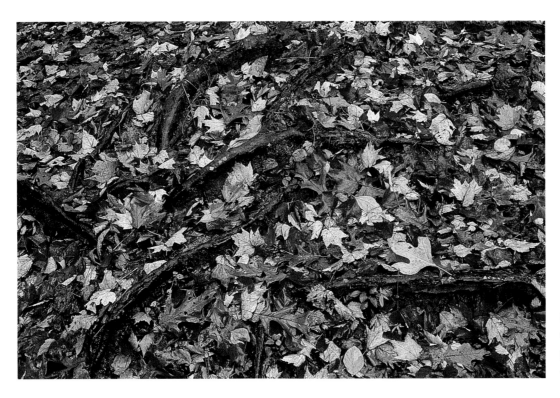

Recarpeting the forest floor, various autumn leaves upon exposed tree roots.

shapes as they develop at odd angles until they can free themselves to once again reach skyward to meet the sun.

Catching the kiss of sunshine is the culminating wonder of tree design, performed mainly by the tree's leaves. Leaves enrich the splendor of the forest with their myriad shapes, sizes, and multilayered arrangements, all of which serve the leaves' specialized function of forming organic compounds basic to the food chain. This occurs through a unique process that captures energy from sunlight and carbon dioxide from the atmosphere and transforms these with raw sap to pro-duce life-supporting compounds such as starch and sugar. At the center of this process is the special pigment chlorophyll, the enabler of photosynthesis and the substance that colors plants green.

In the springtime, the greening of the forest progresses in stages, beginning with various shades of pastel as the amount of chlorophyll increases gradually with the increasing sunlight. Conversely, the colors of autumn are attributable to the emerging dominance of other pigments, including various reds and yellows, accumulated during the summer and now more visible

The giving tree. A dead tree gives of its decaying body to support new growth.

as chlorophyll decreases with the approach of winter and waning sunlight. The falling leaves of autumn are but one tactic, together with receding sap and other measures, by which trees protect their vital functions during winter hibernation.

Trees compete for space and sunlight in the forest by means of their adaptations to different niches. Most dominant tree species in a forest are those whose mature crowns extend side by side in a relatively continuous, solid expanse that forms the top layer of the forest, the forest canopy. Typical canopy trees in Alabama are often those for which a given type of forest is named. For example, in the oak-hickory forests of Alabama's Appalachian foothills, the forest canopy is largely comprised of prevalent species of oaks and hick-ories. In the pine forests of south Alabama's pine hills, canopy trees are, of course, those species of pines that have established in a given setting. Likewise, in other parts of Alabama, the typical canopy of the "mixed" southern hardwood forests is a wider mix of species, usually including several species of red oaks, white oaks, tuliptree, and sweetgum.

Beneath the forest canopy, the next layer of trees—the forest understory—is comprised of species that are better adapted to survival in shadier environs. Many of these, including ironwood, sourwood, black cherry, and mulberry, are more common to the understory of hardwood forests, while others, including dogwood, holly, sweet bay, and locust, are found in the understory of a wide range of forests across the state.

*Forest Communities*

The wondrous variety of Alabama trees, impressive to biologists since the time of William Bartram, is minimized by our tendency to speak of Alabama's forest diversity in simple terms, as "hardwoods" or "pines." Even state forestry officials are prone to make this overgeneralization, dividing Alabama into five major forest types: longleaf pine-slash pine, loblolly pine-shortleaf pine, oak-pine, oak-hickory, and oak-gum-cypress. These categories are helpful to the extent that they match major areas of the state with common kinds of forest dominance, as shown in map 1. However, Alabama's forest diversity is far richer than such a simplified portrayal indicates.

The many combinations of geology, soils, and hydrology across Alabama result in a kaleidoscope of forest adaptations. These forest variations have been correlated with the numerous physiographic and geological variations in the state, as documented, for example, by Roland Harper in his famous 1943 report, "Forests of Alabama." Harper describes twenty-one "natural divisions," from the "chert belt" of uppermost north Alabama to the "coast strip" where Alabama merges with the Gulf, each with notable differences in forest characteristics.

Today Alabama's diverse landscapes are also examined according to such parameters as "ecoregions" (see map 2), which facilitate the study of ecosystems and their associated habitats for flora and fauna. This eco-logical perspective provides a framework in which to further describe the state's forest diversity—including the remarkable reality that Alabama is home to more than seventy different forest communities, each with its own distinctive alliance of tree species.

Alabama's forest communities exemplify the axiom that "the whole is greater than the sum of its parts." In each forest community, the various parts—soils, plants, and animals—have, over time, become established together as an interdependent living system. Like human communities, forest communities are sustained through their interrelationships with the various members of the community.

Local soils underlie the development of local forest characteristics. Alabama's diverse geology is the basis of more than three hundred soil types. These provide microbes, fungi, and various nutrients that serve to match suitable soils with suitable forests, ranging from the wetland soils of lowland cypress forests, to the sandy soils of coastal plain pine forests, to the loamy soils of upland cove hardwood forests.

Alabama's geology is also the basis of varied hydrological conditions across the state. Subsequently, Alabama's diverse rivers and aquatic areas are found in relation to different forests, from the oak-hickory forests along rocky streams and lakes in the northern highlands to the tupelo-bay forests of alluvial river bottoms and marshes in the south.

Likewise, most of the state's fish and wildlife species

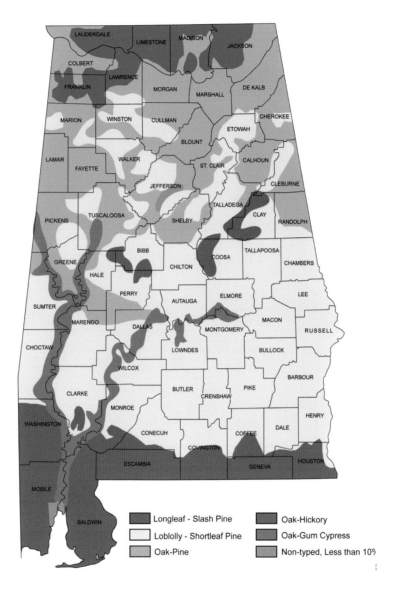

Alabama forest types. Courtesy of Cartographic Research Lab, University of Alabama.

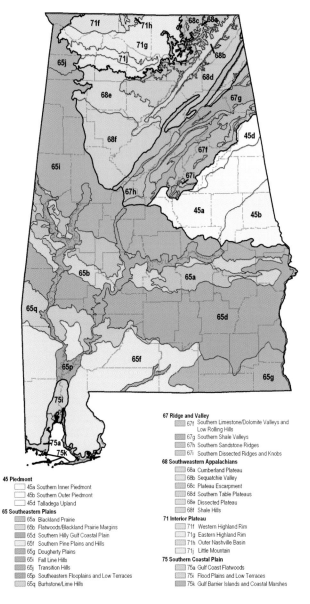

**67 Ridge and Valley**
- 67f Southern Limestone/Dolomite Valleys and Low Rolling Hills
- 67g Southern Shale Valleys
- 67h Southern Sandstone Ridges
- 67i Southern Dissected Ridges and Knobs

**68 Southwestern Appalachians**
- 68a Cumberland Plateau
- 68b Sequatchie Valley
- 68c Plateau Escarpment
- 68d Southern Table Plateaus
- 68e Dissected Plateau
- 68f Shale Hills

**71 Interior Plateau**
- 71f Western Highland Rim
- 71g Eastern Highland Rim
- 71h Outer Nashville Basin
- 71j Little Mountain

**75 Southern Coastal Plain**
- 75a Gulf Coast Flatwoods
- 75i Flood Plains and Low Terraces
- 75k Gulf Barrier Islands and Coastal Marshes

**45 Piedmont**
- 45a Southern Inner Piedmont
- 45b Southern Outer Piedmont
- 45d Talladega Upland

**65 Southeastern Plains**
- 65a Blackland Prairie
- 65b Flatwoods/Blackland Prairie Margins
- 65d Southern Hilly Gulf Coastal Plain
- 65f Southern Pine Plains and Hills
- 65g Dougherty Plains
- 65i Fall Line Hills
- 65j Transition Hills
- 65p Southeastern Flooplains and Low Terraces
- 65q Burhstone/Lime Hills

Alabama's ecoregions. Reproduced by permission from R. Mirarchi, ed., *Alabama Wildlife*, vol. 1 (Tuscaloosa: University of Alabama Press, 2004).

Sweetgum tree *(Liquidambar styraciflua)* in one of its many autumn renderings. The sweetgum displays a great variety of fall colors—many shades of red, yellow, and purple—sometimes all on the same tree.

Adversity adds diversity. Such an odd configuration is usually the result of a tree's struggle to grow around a fallen obstacle or to overcome damage or disease.

can survive only in unique soils of slopes and ravines that are protected by moist broad-leaved forests in the Red Hills region; and aquatic species such as the Cahaba shiner, for whom life-supporting water supply depends largely upon the health of hardwood forests along the upper Cahaba River.

A listing and scientific description of Alabama's many forest communities can be obtained from the Alabama Natural Heritage Program, with offices currently on the campus of Huntington College in Montgomery, or from the Alabama Department of Conservation and Natural Resources, State Lands Division, Natural Heritage Section.

### Ownership

Property ownership is, of course, a major determinant of forest conditions in Alabama. There are more than 210,000 forestland owners in the state, each administering their respective properties according to different needs and interests. The result is a wide mixture of forest practices. From county to county, Alabama landscapes exhibit a grand patchwork of timberlands that vary in size, shape, age, and species composition. Such variation is often considered a foremost aspect of forest diversity in the state, attributable to the diverse preferences of Alabama landowners.

Popular myth aside, the majority of Alabama forestlands are not under industry or corporate control. To the contrary, nearly 11 million acres are held by nonin-

are dependent in one way or another on Alabama's forests. Many species require the special conditions of specific forest habitats. This is invariably true for imperiled species including, for example, winged species such as the red-cockaded woodpecker, who prefers the aging trees of maturing longleaf forests; terrestrial species such as the Red Hills salamander, which

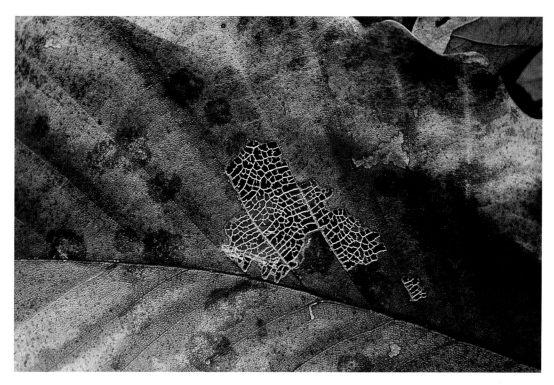

The architecture of Mother Nature revealed in the support structure of a dead leaf.

dustrial "small" landowners with parcels averaging less than 100 acres, and another 5 million acres belong to nonindustrial "large" landowners with tracts greater than 500 acres.

These private landowners include many individuals and families who strive diligently to be good stewards of their lands. Several represent names among the ranks of notable conservation leaders.

For example, the 5,300 dedicated acres of the Solon Dixon Forestry Education Center, located in Covington and Escambia counties, are a legacy of the late Solon Dixon, an early champion of forest conservation in

Alabama. Similarly, the 5,500 protected acres of the Fred T. Stimpson Wildlife Sanctuary, located in Clarke County, are a tribute to several generations of responsible land stewardship by the Stimpson family. Visitors to such family timberlands today will find highly productive forests with many special qualities. For example, most of Alabama's champion trees (largest living member of a species) are found on private lands, thanks to the attention of caring landowners.

Forest industry ownership in Alabama totals about 4 million acres, and the forestland holdings of various other corporate owners add up to around 1.5 million

acres. These properties typically range in size from several hundred to several thousand acres and often contain some of the larger tracts of continuous forestlands found across Alabama's rural countryside.

In many cases, industry lands are managed intensively for commercial timber production, but recreation has become a major activity as well. Most owners accept leasing arrangements with hunting clubs or other groups. Several companies offer select hunting opportunities at choice accommodations such as the famed Westervelt Lodge operated by Gulf States Paper Corporation.

Government ownership accounts for the remainder of Alabama's forestlands, or a bit more than a million acres. Federal agencies oversee about 800,000 acres, including 660,000 acres of national forests, with the rest comprised of wildlife refuges, special preserves, and military properties. The state of Alabama controls roughly 300,000 acres, distributed geographically in varying parcels as state parks, state forests, and protected wildlands and wildlife management areas.

For the most part, government-owned lands are public lands, open to public use (an obvious exception is military property) and designated differently for a range of purposes.

Among federally managed lands in Alabama are four national forests, the William B. Bankhead, Tuskegee, Conecuh, and three divisions (the Shoal Creek, Oakmulgee, and Talladega divisions) of the Talladega National Forest. National forests are supervised by the U.S. Forest Service, whose mission is to provide "multiple-use" stewardship for "soil, water, wildlife, timber, and recreation." These lands are especially large and are great for hiking, camping, and all kinds of nature study, though certain user restrictions apply.

The national forests of Alabama also contain the state's three federally designated "wilderness" preserves, the Sipsey Wilderness Area, Cheaha Wilderness Area, and Dugger Mountain Wilderness Area. The purpose of these areas is to permanently protect impressive wildlands that still reflect pristine qualities reminiscent of the native American wilderness. Hikers into the Sipsey Wilderness Area, for example, will encounter miles of hidden, misty coves and ancient hardwood forests that exude a rare primeval appeal.

Public lands managed by the state are also treasures of exceptional forest beauty, from the mountain hardwoods of DeSoto State Park, for example, to the coastal pinelands of Gulf State Park, and from game-rich forests in the Barbour County Wildlife Management Area to the cypress-shrouded wetlands of the Mobile-Tensaw Delta that are part of Alabama's Forever Wild Program.

In addition, public lands provide special opportunities to protect and restore imperiled species, thus the nationally recognized bald eagle recovery project begun at Guntersville State Park and the celebrated efforts to restore red-cockaded woodpecker populations in Alabama's national forests.

A colorful canopy canvas, Bankhead National Forest.

Virginia creeper *(Parthenocissus quinquefolia)* usually exhibits fall color long before the host tree.

Endangered red-cockaded woodpecker *(Picoides borealis)* nesting in the heart of a southern pine. The bird opens small wounds in the bark around the nest entrance, releasing pine rosin, which deters predators.

Likewise, forested portions of such public lands as the Wheeler National Wildlife Refuge and the Bon Secour National Wildlife Refuge are administered by the U.S. Fish and Wildlife Service as part of their charge to perpetuate American wildlife.

Often the conservation missions of state and federal agencies are aided by the thoughtful acquisition of significant lands and waters by nongovernment organizations like the Nature Conservancy and a host of citizen-run land trusts. Such groups have contributed immensely to the protection of Alabama's natural heritage through their purchase of many thousands of acres of important lands, from the remarkable Grand Bay Savannah pinelands along the Gulf Coast to the rare Bibb County Glades tract bordering the Cahaba River.

Even Alabama's military lands are often managed for the benefit of nature. This includes the U.S. Army's release of nine thousand acres of unique forestland within the boundary of Fort McClellan near Anniston, dedicated in 2003 as a protected preserve for wildlife and for the mountain longleaf.

Returning a red-cockaded woodpecker chick to the nest after leg banding by U.S. Forest Service personnel, Talladega National Forest.

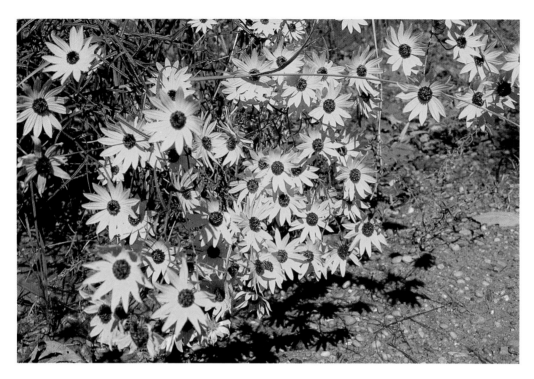

Narrow-leaved sunflower
*(Helianthus angustifolius)*
along forest roadside.

## FOREST VALUES

Alabama forests are a cornucopia of values, supporting all aspects of life in the state. Some of these values are readily recognized. For example, classroom science books typically include mention of basic forest roles and contributions. However, many forest values are less familiar to a mainstream society today that has little direct contact with the land. Still, the lives of all Alabamians, whether urban, suburban, or rural, are enriched by a multitude of benefits from Alabama's forests.

### *Economic Values*

The economic contribution of Alabama's forests is huge. Indeed timber ranks as the number one agricultural "crop" in Alabama. The dollar value of timber harvested annually is more than double that of other major agricultural crops in the state.

The forest industry is active throughout Alabama with commercially grown forests, logging companies, and hauling companies in every county, supplying wood for more than a thousand forest products operations.

Primary processors include 196 sawmills, 27 veneer mills, 20 pole mills, and 15 pulp and paper mills. There

Slash pine *(Pinus elliottii)* in spring.

are many hundreds of secondary manufacturers that produce a myriad of wood-related products.

The economic impacts of forestry are measured differently by different sources, but all agree, Alabama's forest industry is big business. Roughly 65,000 Alabamians are employed directly with wood products businesses, and as many as 200,000 additional Alabama jobs are supported in one way or another by forestry and the forest industry. In terms of overall output, Alabama's forest products businesses generate a value-added economic worth exceeding 10 billion dollars annually.

Such big-dollar aspects of the forest industry are widely publicized by various organizations in Alabama. Less recognized, however, is the extent to which commercial forest products permeate our homes, schools, and workplaces, touching virtually every aspect of daily life.

Our society today uses more than five thousand different wood-related products in the form of various fibers, chemicals, extracts, and compounds. From day to day, each of us may enjoy as many as several hundred of these items, including medicines, clothing, packaging, fuels, dyes, resins, musical instruments, photographs, cosmetics, and adhesives—not to mention such com-

monly known wood products as furniture, paper, and building materials.

Recreation provides another often unrecognized economic value of Alabama forests. The state's abundant forestlands provide excellent settings for all manner of outdoor interests and pursuits, including hunting, fishing, camping, boating, backpacking, bird-watching, and plain old strolling in the woods. Alabama forests have recreational appeal within the state and among outdoor enthusiasts from across the nation, and draw millions of users annually. All totaled, the revenue generated from forest recreation, from the sales of hunting licenses to the purchase of food and lodging, is once again in the billions of dollars.

Alabamians may be so accustomed to the state's plenitude of woodlands that they tend to sometimes take such surroundings for granted. But a growing number of people from outside the state consider Alabama's forests uniquely attractive, not only for recreation, but also for living and working. No doubt this allure has been an operative factor in bringing scores of economic gains to Alabama through the location of new industry and other kinds of development in the state.

Possibly the most overlooked economic value of Alabama forests is their role in contributing a variety of "free services," tangible benefits that would otherwise require taxpayer support to provide. For example, where healthy forests drape the watersheds of Alabama rivers, water quality is protected by the forests' capacity to buffer the streams and contain pollutants. Likewise, the function of the state's forests in helping maintain air quality is not only an environmental benefit but represents a significant economic value. The economic consequences of losing such forest contributions are readily seen in the higher costs for water treatment, pollution control, health problems, and regulatory expenses associated with sprawling urban regions where these forest values are absent.

## Environmental Values

An old adage asserts "the nature of life is nature," succinctly reminding us that life as we know it depends fundamentally upon the natural order of the world. All benefits that man derives from the forest, including the economic benefits noted above, accrue by grace of Mother Nature. Nature also directs the vital functions of equilibrium for her own realm.

Foremost among these is the overarching role of healthy forests in sustaining essential environmental processes. Certainly forests are important to air quality, by taking in carbon dioxide and giving off oxygen. And certainly forests are important to water quality, by softening the impact of rain and by developing loamy soils that capture rainfall, filtering and releasing a steady supply of clean water to our rivers, lakes, and groundwater aquifers.

Alabama's forestlands also benefit the environment in many ways that are not so commonly recognized.

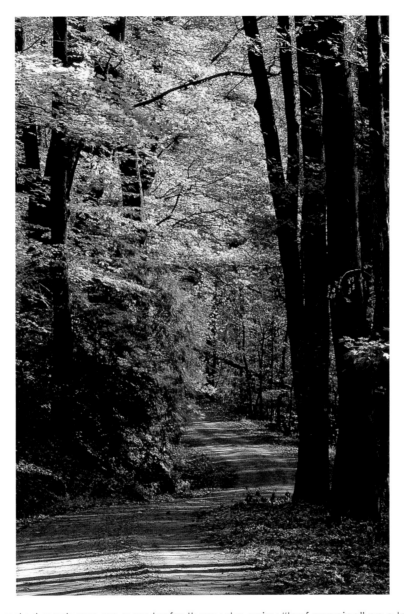

Alabama's forested roadways are popular for those who enjoy "leaf peeping" on a lovely fall day.

For example, the state's vast forestlands transpire great amounts of water into the atmosphere, helping maintain our region's temperate climate and feeding the global water cycle. At the same time, Alabama's extensive forest cover greatly moderates the effects of a searing sun. Summer humidity may be an aggravation for many Alabamians, but the heat would surely be more extreme without the cooling effects of plentiful forested surroundings.

Among the greatest values of Alabama forests is the tremendous scope of biological diversity they nurture. The state's varied forestlands provide habitat for thousands of species of plants and animals. In fact, most of Alabama's flora and fauna are historically associated with forested landscapes, whether a given species is more suited to the forest canopy or to the forest clearing, to forest marsh or forest meadow.

For instance, here and there beneath aging upland forests are the petite blooms of spotted wintergreen and partridgeberry, spicing the forest air with their subtle, sweet smells. Forest openings often accommodate more stately forbs such as spiderwort and boneset, tickling the forest grandeur with their odd configurations. Forest edges, meadows, and roadsides typically display such seasonal wildflowers as bird-foot violets, evening primrose, asters, and goldenrods, teasing the forest serenity with their dazzling wild beauty.

A trek through an Alabama forest will also reveal a variety of colorful climbing vines, including trumpet

Jack-in-the-pulpits *(Arisaema triphyllum)* blooming under protective tree cover.

creeper, jessamine, and crossvine; numerous delightful ferns such as lady fern, wood fern, and spleenwort; and a host of less conspicuous plants—grasses, sedges, and lichens—that together amplify the floral exuberance of Alabama's forests from limb to loam.

The abundance and variety of animals supported by Alabama forests are unmatched. The state today is rec-

ognized nationwide for its wealth of game animals, particularly deer and turkey, lauded by sportsmen and sportswomen who find Alabama forestlands superior in providing quality hunting experiences.

Nongame wildlife also populate Alabama forests in greater number and variety than found in other states. Especially significant among nongame animals are scores of imperiled species, whose ranks span the spectrum—terrestrial and aquatic. Many were once common across the Southeast; most are now increasingly dependent upon Alabama lands and waters for refuge.

There are more than two hundred wildlife species whose status is of priority concern to state biologists. Among this number are twenty mammals, twenty-six birds, forty amphibians and reptiles, forty-seven fishes, and ninety-six freshwater mussels and snails. The daily lives of many such creatures are intrinsically linked with forested landscapes and watersheds. Examples include the black bear and the eastern spotted skunk, the wood thrush and the worm-eating warbler, the gopher tortoise and the eastern indigo snake, the slack-water darter and the Alabama moccasinshell mussel. In addition to the imperiled species mentioned earlier, a number of such creatures require special forest habitats that are increasingly rare.

Throughout Alabama's forestlands, many other species, game and nongame, are thriving. These include animals of all kinds—raccoon, opossum, fox, bobcat,

Whitetail deer *(Odacoileus virginianus)*, common resident of Alabama forests. Male whitetails lose their antlers following the annual rut. For this fellow, one down and one to go.

Bald eagles *(Haliaeetus leuco-cephalus)* nesting in a dead pine tree, Guntersville State Park.

beaver, owls, woodpeckers, salamanders, frogs, turtles, and snakes.

The numbers compound when we consider yet another realm of forest life. Alabama forests harbor thousands of varieties of beetles, butterflies, grasshoppers, crickets, moths, ants, spiders, bees, wasps, and countless other terrestrial invertebrates. These critters, each in its own way, are basic in the food chain, vital for such needs as pollination and decomposition, and essential to the overall web of life.

The world of forest habitats, plants, and animals in Alabama still exemplifies the mystique of early American wildlands celebrated by writers and artists of the romantic period. Within each forest habitat, whether a hemlock cove, a piney ridge, or a hardwood river bottom, the forest displays nature's ever-enchanting moods, in stirrings and silences, tones and textures, meanders and mysteries. Moreover, this richness of life illustrates the conclusion of many ecologists today—that the lands and waters of Alabama are refuge for an ark of biodiversity unrivaled over much of our Earth.

*Beyond Economics and Environment*
The values of Alabama forests extend beyond their

Sycamore over the Cahaba River, Bibb County. Stream environments often harbor this species.

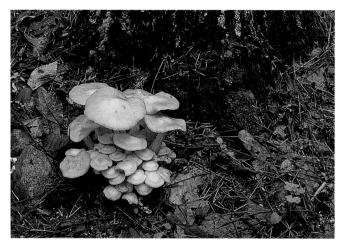

Fungus growth at base of tree.

material and environmental contributions. Additional benefits are often categorized as recreational, social, or educational. Together these are generally regarded as amenities that enhance the quality of life in Alabama. However, such forest values are more than merely amenities and often address needs central to the human quest for meaning and fulfillment.

For example, recreational activities afforded by Alabama forests offer far more than simply the opportunity for escape from the workday routine. As affirmed by famous conservationist Aldo Leopold, the greatest gain from outdoor recreation is its potential to re-create in the human mind a sense of connection to the natural world, to re-create in the human spirit a sense of awe for the grand design. In fact, some would say that this benefit, the gift of personal inspiration and

renewal, is indicative of the forest's spiritual value.

The social values of Alabama's forests are described in various ways from different perspectives. For present purposes, these can be boiled down to some simple basics: a church picnic, a family outing, a hunting trip with friends, a bird-watching adventure with colleagues—these and many other daily doings in Alabama typify not only the quality of life but also the *character* of life in our state. Camaraderie, friendship, and fellowship are all cultivated by a shared bonding with our forest surroundings. These values too are often counted among the spiritually enhancing benefits of Alabama forests. Many of us in Alabama are also uplifted by the plain joy of sitting on the porch amid the peeps of tree frogs at night. We are buoyed by the trip to work along lushly forested roadways. We are even soothed by walks through tree-lined paths and parks in Alabama town centers.

For many Alabamians, family history and heritage are built upon generations of life daily connected to Alabama forestlands. The presence of forests defines our sense of place; the closeness to forests is part of who we are.

The educational aspects of Alabama forests are significant as well. On the one hand, the state's diverse forests represent a living laboratory for scientific research. Already, a broad range of forest research is yielding new knowledge helpful to many fields—economics, ecology, medicine, and other areas.

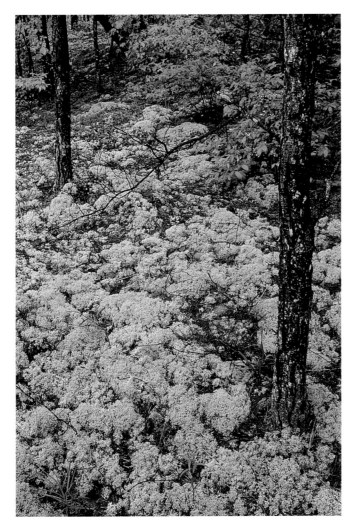

Reindeer moss *(Cladonia subtenuis),* a ground lichen, covers forest floor, spring, Little River Canyon Nature Preserve.

Early winter ice storm encases a lingering leaf of a black-gum tree *(Nyssa sylvatica).*

On the other hand, Alabama's abundant forestlands are exceptional living classrooms, suitable for use by students and educators from all grade levels. As any master teacher can attest, the forest classroom provides students with myriad opportunities for observing, recording, thinking, deducing, imagining, writing, and creating. In the forest are real-world learning aids for the study of science, history, and social studies, for the applied study of language arts, literature, and math.

Even the stump of an aged tree is a useful teaching tool, with its annual growth rings still visible and its roots still embracing the soil that has nourished a long life. The growth rings are a hands-on learning aid for science, for example, by showing the variable rate of tree growth in relation to annual weather conditions. Math is easily incorporated through the measuring and calculating necessary to draw conclusions that reveal changing climate patterns over time. And often of greatest intrigue, such an old tree stump contains a

"living" record of history, marking the birth year of the student, the teacher, parents, grandparents, and maybe even the life spans of great-grandparents. In fact, the rings of a very old tree will signify such key moments in history as the signing of the Declaration of Independence, and before that, the landing of pilgrims, or possibly earlier still, explorer Christopher Columbus' arrival to the New World. The study of life in the forest can be a history lesson enriched beyond the mere recitation of dates and events. It can provide a genuine visit back in time, a direct encounter with an actual witness to history.

Conversely, the forest classroom can help us ponder the future. As the forest continues to grow, how many years will nature grant? How many will man allow? Which years will mark periods of peace and prosperity; which will see times of trouble and travail? And who, someday far in the future, might stop to examine the forest record and muse upon our own history past?

Weathered wood, the handicraft of nature on a fallen tree.

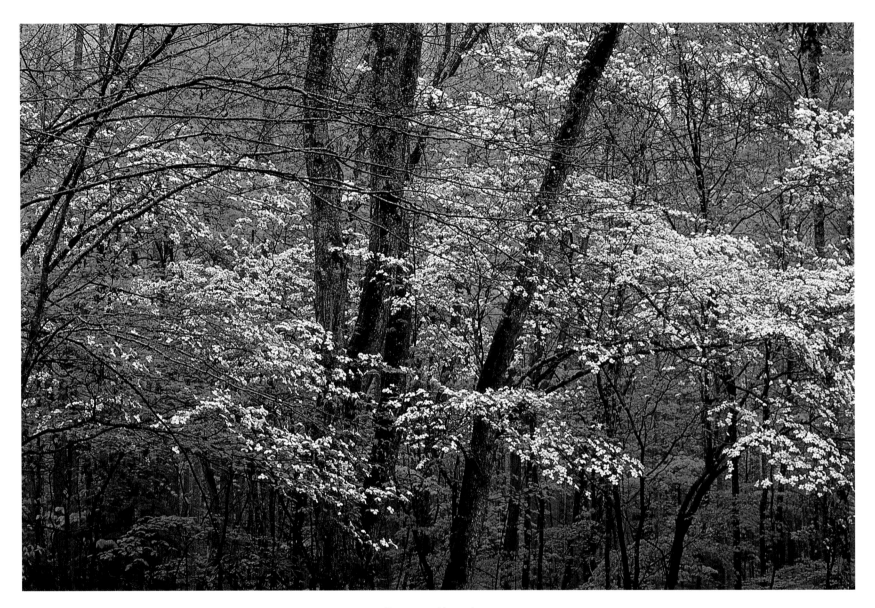

Dogwood in spring.

Dogwood in autumn.

Dogwood in winter.

# FORESTS FOR THE FUTURE

*In the woods we return to reason and faith.* —Ralph Waldo Emerson

ALABAMIANS CAN BE PROUD THAT THEIR bountiful forestlands have contributed so fully to the history of the state, shaping lives and lifeways from the time of native cultures to the present. And now, as we enter a new millennium, what does the future hold for our forestlands and our connection to them?

## THE CHALLENGE

Although the productivity of today's forests has been restored, all is not necessarily well on the forest front. Obviously the wooded Alabama backcountry is far from impending environmental doom; however, Alabama's forests are the subject of a host of environmental concerns. Indeed the management of Alabama forests has long been an item of intense controversy.

*Lingering Issues*

The classic divide, of course, separates environmental groups and the commercial timber industry. Today, however, the lines between the two interests are sometimes blurred when industry claims to be the true protector of the environment and environmentalists profess their concern for the economy. This struggle for the moral high ground would be humorous if it did not involve serious conflicts over methods of timber harvesting, use of chemical herbicides, protection for endangered species, preservation of wilderness areas, and other weighty issues.

Many forest issues are very complex, too much so for meaningful dissection by the traditional media, which sometimes only confound public understanding about such matters. An example is the issue of converting nat-

Winter in the forest. Pine needles collect heavy volumes of snow and ice, often enough to bring down the tree.

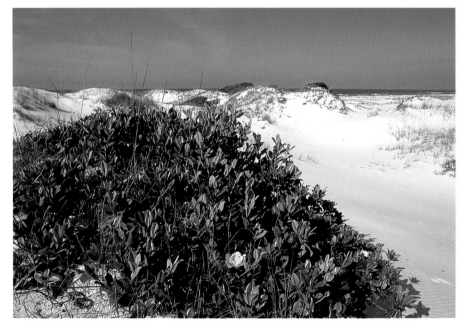

Southern magnolia *(Magnolia grandiflora)*, commonly found in maritime environs but here established in an uncommon fashion, rooted in a soil bank adjacent to sand dunes.

ural forests to commercial pine plantations. News stories have reported environmental groups' concerns about this practice but sometimes leave readers with the singular impression that pine plantations are rapidly replacing Alabama's hardwood forests. Rarely is it reported that pine plantations are often the result of planting old farm fields and pastures, where they actually help to stabilize and rebuild soil. But, then, news reports also typically fail to acknowledge that fast-growing commercial pines often produce wood that is inferior to the quality of timber from natural woodlands. However, neither is the public usually informed that this concentration of commercial forest production through such means as pine plantations may help maintain the majority of Alabama forests for ecological and recreational values. Then again, rarely is the public alerted to the potential for future harm to the majority of Alabama's forests from unrestrained, escalating market forces. And these are just a few of the numerous point-counterpoint complexities associated with only this one forest issue.

Obviously analysis of such complex issues would be too lengthy for the remaining pages of this book. The good news is, Alabama has made important progress in reducing contentiousness in several areas of forest controversy. Still, political dispute is predictable where special interests and commercial profits are at stake. We can expect that, unless lingering issues are effectively resolved, angry conflict will flare anew in the years

Red cedar *(Juniperus virginiana)* rooted on the precipice at Little River Canyon Nature Preserve.

Eastern bluebird *(Sialia sialis)* nesting in a dead tree, Perry County.

ahead. When warring interest groups become polarized, forest policy is often decided by political and legal maneuvering rather than through reasoned problem-solving. Rarely does this spell the best chances for long-term forest health.

## Looming Concerns

Most impacts to our forests have origins close to home:

we need only look into the mirror to face the reality that we, the consuming public, are the ultimate source of rising demands on our forests. This fact pertains beyond the consumption of wood-related products. An ever-expanding human population spells new pressures on forest resources in many ways. Since 1982 population growth and related development in the United States have consumed roughly 20 million acres of forestland.

The conversion of forestlands to sprawling urban/suburban population centers poses environmental dilemmas on a scale most Alabama communities have yet to experience. Foremost among these is the prospect of mounting water problems.

Many American cities are struggling with the phenomenon of rapid rainwater runoff across vast landscapes of concrete and asphalt, mingled with active construction sites of exposed soil. The accumulated sediments, discarded litter and garbage, and residues of gasoline and oil can ruin the water quality of streams and lakes. Add to this the problem of sewage system overflow during heavy rains, which subjects water sources to yet another concoction of contaminants, bodily wastes, medicines and drug residues, household cleaning fluids, and more.

The conversion of forestland to urban landscapes also robs communities of the forest cover necessary to help capture rainfall and recharge groundwater aquifers. The combination of urban sprawl, diminished

surface waters, and dwindling groundwaters is a formula for serious water shortage.

An urbanizing society also presents new forest dilemmas of an entirely different sort. Daily life for the typical urban/suburban resident involves little direct contact with the land. Younger generations today are growing up without firsthand experiences in the rural countryside, without opportunities for nearness to nature during the vital developmental periods of a child's life—without any chance to form close, personal bonds with Alabama's outdoors. Against this kind of cultural change, how long will Alabama's forest heritage remain a meaningful part of our sense of place, our sense of identity?

Ironically the more society becomes removed from the forest, the more there seems to be a need for periodic escape to the forest. As the human population increases, difficulties regarding recreational use of forests will undoubtedly multiply. Already in Alabama, we see growing competition for forest access among hunters and hikers, off-roaders and bird-watchers, revelers and seekers of solitude. This is a dilemma of special difficulty for Alabama's national forests and other public lands. Government agencies responsible for managing these lands face a growing quandary as they try to satisfy conflicting public demands.

Perhaps most troublesome, shifting populations and changing cultural norms tend to affect public lands in ways rarely known heretofore in Alabama. For exam-

During periods of drought, pine trees may shed unusually large amounts of needles to reduce loss of moisture.

Trees in the urban environment, University of Alabama campus, Tuscaloosa County.

ple, crime and vandalism are already common fare in national forests and parklands elsewhere in the nation. A rising incidence of such problems in Alabama will dramatically alter the style of recreational experience enjoyed today. Imagine a future in which Alabama's national forests are forced to add a host of user restrictions, permit requirements, access closures, armed patrols, and security cameras at every hidden spot, not to mention new taxes and fees to cover related costs.

Private forestlands, too, will likely undergo changes on a scale presently unforeseen. Most older Alabamians can remember a time when farm and forestland owners in the state would gladly allow neighbors onto their property to hunt, fish, walk, or simply to explore. Access was often allowed even to strangers. Typically the landowner requested only that livestock, fences, and gates be respected, and typically the landowner's request was politely honored. Obviously this situation is changing. Increasingly across Alabama, the welcome mat is removed and the Keep Out! warning prominently displayed. A number of factors contribute to such a shift, but regardless of where blame is assigned, this scenario may be only a hint of things to come.

The current topic of property taxes is very relevant here. As society becomes more and more urbanized, so too the growing needs of urban populations require

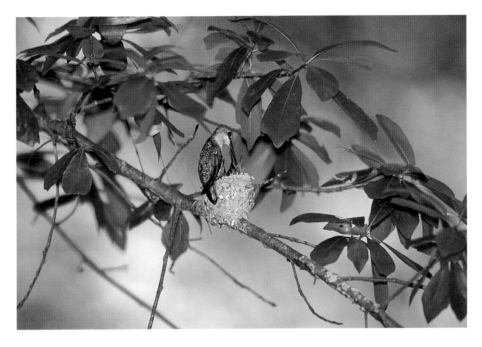

Hummingbird *(Archilochus colubris)* feeding chicks. The nest is woven of various natural materials that are flexible enough to expand as the chicks grow.

increased revenues to support expanding services. As political pressures build, the inevitable finally happens. Property taxes are raised to levels that are difficult for many owners to manage, especially individual and family forestland owners of average means. Thus these forest owners are often forced to clear-cut, sell, or subdivide their lands. Corporate landowners sometimes choose the same options when preparing revised forest plans in response to property tax increases. As a result, large acreages of intact forestlands are soon separated into disparate parcels. Forest habitats are fragmented and isolated.

Of course, the new tax revenues are usually applied to such crucial needs as public schooling, but the question must be asked, is there not a better way to support education that does not harm Alabama farms and forestlands? What will we say has been the value of our schools when the world around them is left void of native wilds and wonders? What ultimate good can we claim of an educational system complicit in blinding us to the natural systems upon which life depends?

Scores of other potential impacts warrant consideration as we ponder the future of Alabama's forests. For present purposes, however, one last area of concern must be included, global change. Recent evidence suggests that global climate change is occurring more rap-

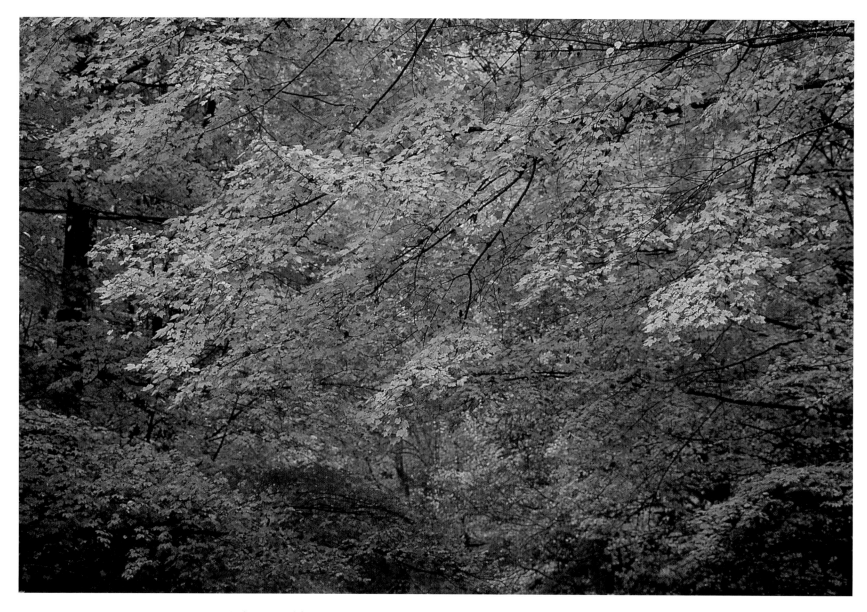

Autumn ambience. A warm, "soft" day in early fall, Guntersville State Park.

idly than scientists first predicted. We now hear projections of disrupting effects on flora, fauna, and entire ecosystems by as early as the year 2050.

True, there is disagreement among some camps regarding the full causes of global climate change. However, there is no disagreement that rising levels of atmospheric carbon dioxide are a primary culprit. There is also no disagreement that global rates of deforestation only exacerbate the problem. Against this backdrop, the carbon-sequestering capacity of Alabama's abundant forests becomes increasingly important, both to Alabamians and to the global atmosphere.

Scientists also warn that global change will contribute to the loss of as much as 25 percent of the world's plant and animal species by some point around the middle of this century. Here again, the uncommon biodiversity of Alabama's forests shines even brighter in global significance.

As the effects of global change intensify, implications for protecting the state's forestlands will compound greatly. Presently in Alabama, many tracts of forestland are benefiting from deliberate management to enhance native biodiversity and native ecosystems. However, as global climate patterns shift, Alabama's natural forests could begin to migrate north and change ecological composition in turn. Dare we surmise, this may require a whole new paradigm of forest management.

Finally, global change is likely to multiply a number of problems that already affect Alabama forests. These include such problems as plant disease, insect pests, and harmful invasive species that often arrive not only with the help of an altered climate, but also frequently as byproducts of changing patterns of global commerce and trade. Certainly global trade and other such economic advances can bring many benefits. On the other hand, these pursuits can also bring ecological disaster unless we are aware of this possibility and take every necessary precaution.

## The Opportunity

Alabama's forests cannot escape the probability of impacts presently unforeseen, nor can the state avoid all forest controversy. However, Alabama's great plenitude of forests allows ample room, literally and figuratively, for tolerance among interest groups and collaboration among forest stakeholders. Voilà! Alabama is making a number of important strides.

### Continuing Cooperation

In recent years, old tendencies to conflagration have been supplanted by a willingness for rapprochement, as many leaders of industry, environmental groups, and government agencies pursue a new commitment to cooperation for Alabama's forests. And the best news is, there are many who are interested in the future of the state's forestlands.

In addition to organizations mentioned earlier, these range from industry-sponsored groups such as the Sustainable Forestry Initiative to citizen-run organizations

Kudzu *(Pueraria lobata)*, often called "the vine that ate the South," is an introduced species capable of totally encasing a mature tree, eventually killing it.

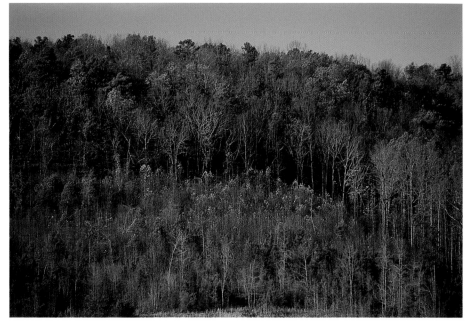

Forest succession following a partial clear-cut, Etowah County. Forest openings, whether created by man or by nature, tend to regenerate in successive stages until regaining naturally dominant cover.

Falling leaf lodged in a dead tree after a windy storm in late September.

like the Alabama Environmental Council. Included are landowner organizations like the Alabama Forestland Owners Association and state-assisted programs such as Alabama Forests Forever.

The Alabama Forestry Association is a major voice of leadership for forest industries in the state. The Alabama Forestry Commission is the state agency for forest owner assistance, forest protection and wildfire suppression, and management of state-owned forests. Through the administration of Alabama's national forests, the U.S. Forest Service oversees the largest portion of federal forestlands in the state.

A host of other organizations contribute in assorted ways. The Alabama Department of Conservation and Natural Resources administers state laws and policies pertaining to fish and wildlife, state parks, state lands, and the Alabama Forever Wild Program. The Alabama Treasure Forest Landowners Association supports and promotes the Alabama Treasure Forest Program. And, the Alabama Forest Resources Center provides cooperative leadership for forest research and information sharing. Not to be overlooked are the many organizations promoting urban forestry to ensure the continued benefit of trees for Alabama's cities and towns.

There also is a wide supply of ready information on the subject of Alabama forests. A number of informa-

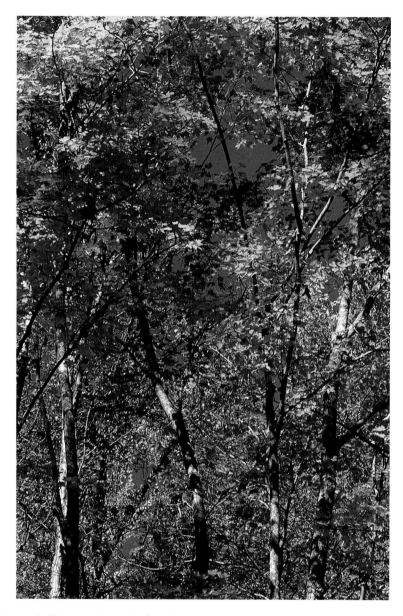

Autumn brilliance. A cool, crisp day well into the season, Mt. Cheaha State Park.

"Paper bark" of river birch *(Betula nigra)* in winter, Russell County.

tional materials are provided by the organizations above. Other helpful sources include, for example, the Alabama Wildlife Federation, assisting forestland owners with such notable publications as *Managing Wildlife.* And, of course, an array of additional materials, of both scientific and general content, are available from universities, museums, and public libraries.

The complete list of those involved with Alabama forests is lengthy. For present purposes, it is perhaps appropriate to conclude with mention of the Alabama Forest Planning Committee, a body of twenty-two organizations—colleges, professional groups, private and public interest groups, and state and federal agencies—that cooperate closely on behalf of Alabama's forests. The Alabama Forestry Commission, headquar-

tered in Montgomery, can provide further information about the committee.

In many respects, the level of networking and cooperation attained among Alabama forest stakeholders places the state ahead of other parts of the nation. Alabamians have a key opportunity to build upon this spirit of cooperation in planning and preparing for the future sustainability of Alabama forests.

### Recommended Actions

We cannot deny the reality that Alabama is confronted by many economic needs. On the other hand, the state is likely to see plenty of gains in the years ahead. Assuming no global economic collapse or other such world catastrophe, we can safely anticipate that the South will

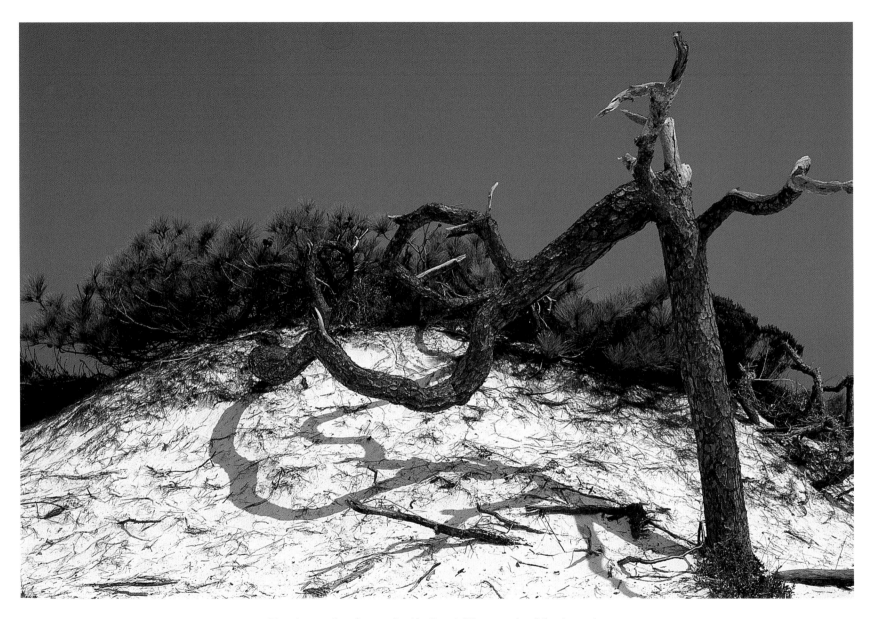

Pine trees cling for survival in the shifting sands of the beach.

remain a region of accelerating growth and that Alabama will continue to attract expanding development and a growing human population, together with attendant forest impacts described above. How then might Alabamians best prepare to sustain plentiful forestlands for the long term?

This question is examined in at least a dozen of the programs in the *Discovering Alabama* series (to date, the series includes a total of more than sixty shows covering all aspects of the state's natural history). In the production of these shows, *Discovering Alabama* has worked closely with landowners, foresters, scientists, environmentalists, industry, and state and federal agencies. The series has enjoyed the honor of serving these interest groups in helping Alabama establish many important forest conservation projects and programs, including the Alabama Natural Heritage Program, the Treasure Forest Program, and the Forever Wild Program. This experience provides useful context for offering a number of recommendations for the future of Alabama's forests.

**Recommendation 1. Promote Increased Public Education about Alabama's Forest Heritage.** The cooperative efforts of many organizations have produced a variety of forest education opportunities and materials, for the general public and, most importantly, for Alabama schools. In addition to pertinent *Discovering Alabama* programs, there are, for example, the Forests Forever Program, established in the state by the Alabama Forestry Commission; Project Learning Tree, provided to schools by the Alabama Forestry Association; the Outdoor Classroom Program, offered by the Alabama Wildlife Federation; and a host of posters, pamphlets, and instructional materials sponsored by industry and by conservation groups. Also, many such organizations conduct forest education field trips and workshops designed especially to assist Alabama schools.

Unfortunately these fine efforts are reaching only a small percentage of Alabamians. The reason for this limited success is partly societal—today's urbanizing society is oriented to other interests—and partly institutional. That is, K–12 schooling in Alabama requires relatively little in the way of environmental education. There is no teacher certification in this regard, no state environmental education curriculum, no standards for measuring environmental literacy, and no formal guidance to help teachers select and incorporate appropriate materials into their teaching. In other words, the inclusion of environmental education in Alabama classrooms is optional, a voluntary choice left to the discretion of individual teachers who typically have little or no relevant training.

Meanwhile teachers are overly burdened by the increased requirements of mandated instruction, classroom management, parent consultations, school committees, mounting paperwork, and the ever-shifting politics of accountability and testing. Add to this a host

Decomposing dead tree hosts other life. Fungi aid the process of decomposition and nutrient recycling.

of complicating pressures that result from today's changing communities and changing values, and most teachers find it prohibitively difficult to commit time to the cause of environmental education.

Nevertheless, the fact remains that the nature of life *is* nature. A good basic education should include a proficient understanding of our basic life support system, including the multifaceted role of our forests. Institutional and political barriers to such an education must be overcome. Accomplishing this will require bold, active support from state leaders willing to strongly and publicly promote greater environmental education in Alabama.

Also, our schools and teachers need a means of conducting environmental education that is systematically supportive of other educational goals and requirements. In other words, they need a method of incorporating environmental learning that helps to ease rather than to increase the complexity of demands presently confronting them. Such an approach is provided by the innovative model program, *Discovering Our Heritage—A Community Collaborative Approach,* being offered to Alabama schools by the Alabama Wildlife Federation in partnership with the Alabama Museum of Natural History and the Alabama Cooperative Extension System.

**Recommendation 2. Develop a Comprehensive Statewide Conservation Plan.** Forest protection in Alabama benefits today from a number of conservation efforts. The Treasure Forest Program brings together

Winter in the forest, northern Alabama.

the expertise of several agencies to work with landowners for wise forest management. The Forever Wild Program joins other state lands programs in securing long-term conservation for special tracts of forestland across the state. Also, many forestland owners are taking advantage of options such as conservation easements, which provide tax breaks and other incentives in return for preserving selected forestlands. However, given that Alabama is sure to experience accelerating change in the decades ahead, these protective efforts, as significant as they are, may turn out to be woefully insufficient. A more comprehensive approach to forest conservation is needed if we hope to retain Alabama's diverse and plentiful forestlands for the very long term. While effective forest education is a priority, this must be accompanied by an ongoing statewide inventory of forestland diversity and forest habitats, together with a comprehensive conservation plan that includes ample incentives for perpetuating abundant forest acreage, forest communities, and forest health in the state. Yes, this idea is likely to meet with the dismissive label *ambitious,* but the same was said about the proposal for Alabama's Forever Wild Program, now recognized nationally as a model for land conservation, which prompts the third recommendation.

**Recommendation 3. Implement a Formal Process for Conflict Resolution.** Thanks to the cooperative spirit of various organizations, Alabama has seen progress in

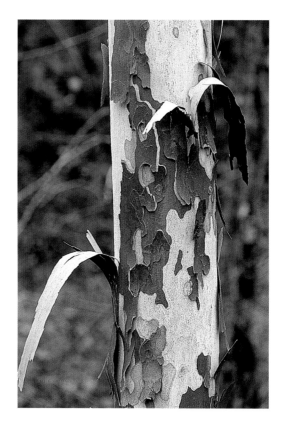

An up close look at the sycamore with its peeling layers of bark and varied colorization.

resolving many areas of environmental controversy. A case in point is the successful Forever Wild Program, which to date has secured permanent protection for more than 100,000 acres of special wildlands across the state. This important program was created in 1992 with an unprecedented consensus of support from key organizations representing business, government, landowners, sportsmen, and environmentalists. Such

broad support did not happen spontaneously. To the contrary, these diverse interest groups have historically differed over a long slate of issues—recreation versus preservation, consumptive use versus nonconsumptive use, private ownership versus public ownership, and so on. However, these groups came together voluntarily and agreed to participate in a guided process of conflict resolution and consensus building. The resulting Forever Wild Program is widely praised as an example of stakeholder cooperation, as a win-win approach for protecting significant lands.

Despite such exemplary cooperation, there are yet many Alabama issues, including issues of forest controversy, about which opposing groups remain at odds, if not completely polarized. A number of these conflicts are fueled by plain, old-fashioned competition over self-interests, political turf, or economic gain. Partisanship of this sort, while appropriate in some instances, is increasingly a major hindrance to achieving effective solutions to complex issues of our time. Perhaps more troublesome is that even when conflicting parties choose to put self-interests aside, still they frequently have great difficulty reaching consensus. Often they cannot agree about basic truths that should be easily verified by simply examining pertinent facts. This difficulty arises because factual information is but one element in a quagmire of human influences—psychological, perceptual, emotional, and philosophical—that typically affect communication and understanding.

Juxtaposition. Here a tenacious white oak *(Quercus alba)* appears to be asserting itself against an intruding boulder. The tree's protrusion is the result of layers of scarring developed over years of resisting pressure or injury.

Mist and mystery, beckoning the adventurous hiker, Oak Mountain State Park.

Crossvine *(Bigonia capreolata)* climbs a dead tree still standing.

Therefore, the recommendation that has been made to state leaders many times over the years is offered again—that Alabama would benefit by implementing a formal process of conflict resolution. This process would provide much more than mediation, which the state attorney general's office already offers. Developed correctly, such a process would guide conflicting parties past the communication quagmire and lead them to cooperative problem solving by 1) thoroughly analyzing the issue in question, 2) clarifying pertinent differences of belief and position, and 3) finding a consensus solution.

**Recommendation 4. Establish a State Planning Council for a Sustainable Future.** A funny thing happened on the way to Capitol Hill after the latest gubernatorial election. In fact the same funny thing happens after every such election. Each time the state gets a new governor, soon to follow is a wholesale change in state administration. New appointees take charge of various agencies, hire new staff to gratify their friends, and impose new policies to suit their politics.

Actually this is not such a funny thing, at least not for Alabama taxpayers. Many areas of government require greater consistency of policy and planning to best serve the state. Chief among these are matters that affect patterns of growth, land use, the environment, and the general quality of life for generations to come.

Unfortunately Alabama has no long-term game plan for such considerations. The different state agencies administer their different responsibilities—economic development, transportation, conservation, environmental regulation, public education—but operate without the benefit of a long-range comprehensive plan and, thus, without ample intra-agency collaboration.

This presents an open invitation for the very scenario many Alabamians fear, a future of haphazard development, urban sprawl in many areas, continued rural poverty in other areas, degraded environmental resources, land-use disputes, government by crisis management, and rising taxes aimed at forestalling problems that will only multiply in the absence of comprehensive planning.

Alabama can best avoid such a troubled future by establishing an independent, permanent planning council, involving pertinent divisions of state government

Pitcher plant *(Sarracenia flava)* in pineland bog, Conecuh National Forest.

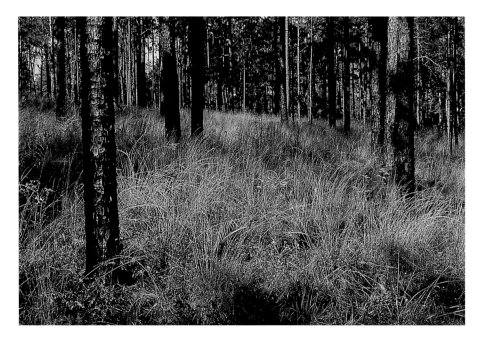

Wiregrass *(Aristida beyrichiana)*, winter, Conecuh National Forest.

but separate from the revolving politics of state government. A primary function of this council should be to freely consider the many issues, options, and contingencies associated with planning and preparing for Alabama's long-term future.

Alabama's unique appeal can be expressed in simple terms as the three *W*s—Alabama has lots of woods, water, and wildlife. If Alabama is to retain its distinguishing abundance of natural qualities, the state must pursue long-range planning that effectively coordinates the three *E*s—educational improvement, economic development, and *environmental management.* Recommendations 1–3 could easily enhance such strategic planning, as would the fifth recommendation.

**Recommendation 5. Heed the Voices of Those Who Feel a Close Bond with the Land.** A key to sustaining Alabama's forest heritage is to embrace the sentiments of Alabamians who yet feel a personal connection to the forest, who still need nearness to wild nature. Too often these voices are left out of committees, councils, and commissions involved with community planning. Too often local officials develop a "vision" for community progress that fails to include a physical vision of native landscapes and natural surroundings.

The concerns of forestland owners, farmers, and others who cherish the land are vitally important for Alabama's future, more so in some ways than are the gentrified notions of urbanites with little comprehen-

Creeping wisteria vine *(Wisteria frutescens).*

sion of the land. When given fair hearing, the resonating message of many landowners is a reminder of things organic as opposed to things artificial. Modern trends may continue to foster a popular preoccupation for fads and superficial consumerism, but the land, the rivers, and the forests remain the real and the fundamental basis of life in Alabama.

Mossy logs in moist ravine, DeSoto State Park.

Bagworms *(Thyridoptez ephemerae-formis)*.

Resurrection fern *(Polypodium polypodioides)*.          Various wildflowers in the cradle of a tree.

Mistletoe *(Phoradendrom serotinum)*.

Mossy tree base with dwarf crested iris *(Iris cristata)*.

# CONCLUSION

## A New Stewardship Perspective

*That land is a community is the basic concept of ecology, but that land is to be loved and respected is an extension of ethics.* —Aldo Leopold

FOR DECADES ALABAMA LEADERS HAVE complained that predominantly rural Alabama is "behind," that the state has failed to attain levels of growth and development common to urban industrial centers elsewhere in the nation. Various efforts to help Alabama "catch up" have won important gains, not the least of which is the famous arrival in 1995 of Mercedes-Benz International, which selected Alabama as the site for the company's first auto manufacturing plant in North America. Ironically company officials acknowledge that part of their attraction to Alabama is the presence of so much rural countryside, an attribute of increasing appeal as other regions develop to the point of losing their natural surroundings.

Certainly continued economic improvement is essential in meeting many of the state's pressing needs. However, if anything is behind the times, it is the sullen assessment that Alabama's ample backcountry is synonymous with being backwards. A new perspective of Alabama is offered today by ecologists who point to the state's forestlands and wildlands as uniquely blessed with biological diversity.

This perspective is given added credence by the revelations of space exploration. One of the earliest space-age "discoveries" occurred when astronauts peered back from the cold darkness of lunar orbit to gaze in awe at the warm, blue, livable Earth. Science today is even more awed by the singular life-supporting significance of our Earth. Despite many distant journeys across the solar system, despite the Hubble telescope's glimpses to the edge of the cosmos, thus far, all other worlds have proven harsh, barren, and lifeless.

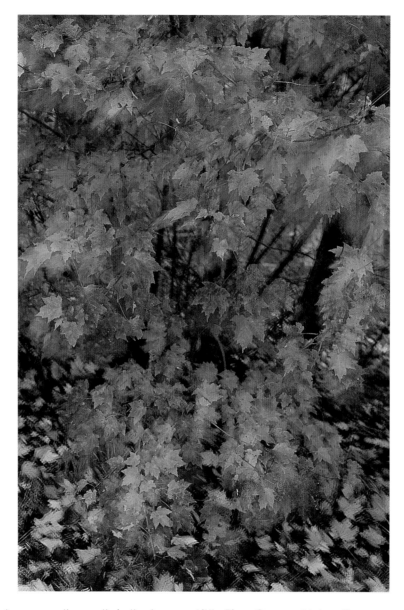

Leaves rustle gently in the breeze, Little River Canyon Nature Preserve.

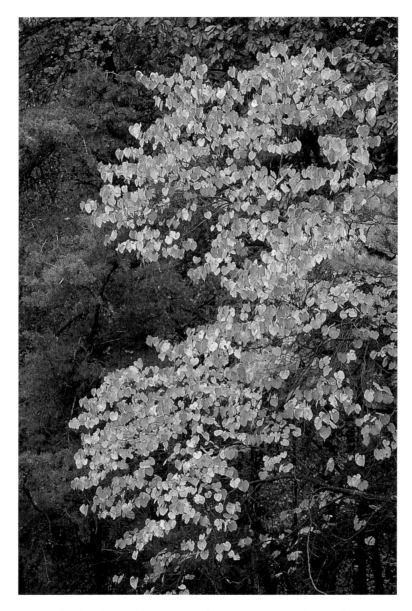

Redbud tree *(Cersis canadensis)*, preparing for winter.

The last leaf of autumn.

To date, all of the life we know to exist in the whole of creation is found only on planet Earth. Among the many lands of this sole living planet, Alabama is increasingly recognized as being especially rich with diverse life. A logical extension is evident: The Earth is profoundly unique in the universe. Alabama is a uniquely diverse region of the Earth. Therefore, Alabama's forestlands and the world of life they support are profoundly unique in the universe.

This realization should hearten those who suffer the notion that the state's "undeveloped" lands are an indication that Alabama is "behind." It should give pause to those who see ruralness as ugliness, who equate backwoods with being backwards.

The perspective ecologists offer reminds us of the biological origins of the words *growth* and *development*, and that these terms apply most fittingly to the wondrous world of forest life. Alabama's forests are contin-ually growing and developing, keeping tempo with nature's cycles and harboring a remarkable abundance of natural wonder. Such natural richness is the distinctive marvel that sets Alabama apart from other regions.

This perspective would suggest that Alabama be prized not for its untapped potential as a region of new industrial corridors but for its unmatched significance as a grand corridor of nature. The new perspective would propose that Alabama be appreciated not for its availability to host sprawling new highway infrastructure but for its opportunity to perpetuate an uncommon wealth of ecological infrastructure.

Alabama's forests are a crown jewel of biodiversity, unique in the universe. As stewards of this unique realm, we can choose to make enlightened choices. The policies and practices we pursue today will determine whether our forestlands are lost or sustained. The future of this profound natural heritage is in our hands.

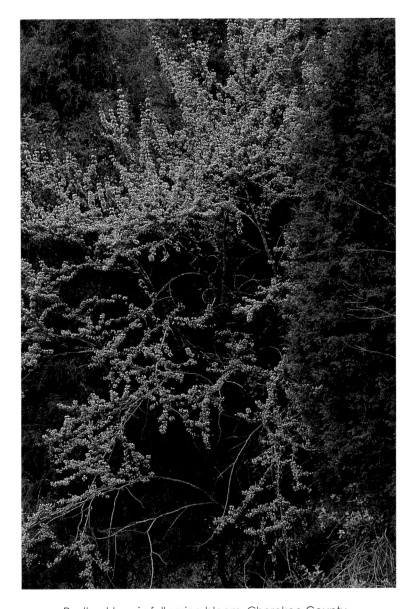

Redbud tree in full spring bloom, Cherokee County.

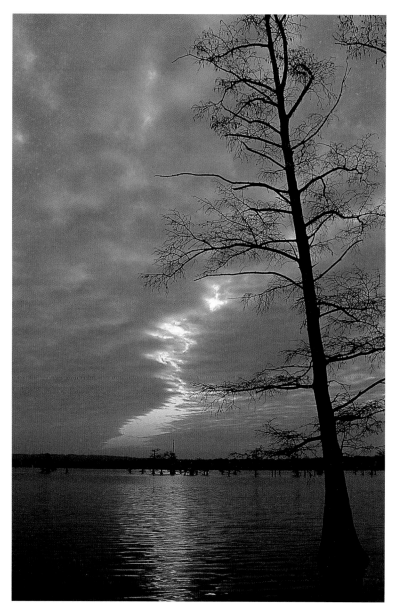

Cypress in coastal backwater, Mobile Bay.

# BIBLIOGRAPHY

"Alabama's Treasured Forests: Index of Articles, Fall 1982–Winter 2000." *Alabama's Treasured Forests* 19, no. 2 (Spring 2000).

Butler, Carroll B. *Treasures of the Longleaf Pines.* Shalimar, Fla.: Tarkel Publishing, 1998.

Clark, Thomas C. *The Greening of the South: The Recovery of Land and Forest.* Lexington: University Press of Kentucky, 1984.

Clayton, Lawrence A., Vernon J. Knight Jr., and Edward C. Moore, eds. *The De Soto Chronicles: The Expedition of Hernando De Soto to North America in 1539–1543.* 2 vols. Tuscaloosa: University of Alabama Press, 1993.

*Conservation Options: A Landowner's Guide.* Washington, D.C.: Land Trust Alliance, 1999.

Davis, Donald E., Norman D. Davis, and Lisa J. Samuelson. *Guide and Key to Alabama Trees.* 5th ed. Dubuque, Iowa: Kendall/Hunt Publishing Co., 1999.

Harper, Roland M. *Monograph 8. Economic Botany of Alabama. Part 1. Geographical report.* Tuscaloosa: Geological Survey of Alabama, 1913.

———. *Monograph 10. Forests of Alabama.* Tuscaloosa: Geological Survey of Alabama, 1943.

Hyman, L. Louis. "Alabama's Fourth Forest." *Alabama's Treasured Forests* 6, no. 2 (Spring 1988).

———. "What Is Alabama's Fourth Forest?" *Alabama's Treasured Forests* 6, no. 1 (Winter 1988).

Kricher, John C. *A Field Guide to Eastern Forests, North America.* Boston: Houghton Mifflin Co., 1988.

Lanzara, Paola, and Mariella Pizzetti. *Simon & Schuster's Guide to Trees.* New York: Simon & Schuster, 1977.

Leavell, Chuck. *Forever Green: The History and Hope of the American Forest.* Dry Branch, Ga.: Evergreen Arts, 2001.

Miller, Char, and Rebecca Staebler. *The Greatest Good: 100 Years of Forestry in America.* 2nd ed. Bethesda, Md.: Society of American Foresters, 2004.

Miller, James H., and Karl V. Miller. *Forest Plants of the Southeast and Their Wildlife Uses.* Auburn, Ala.: Southern Weed Science Society, 1999.

Mirarchi, Ralph E., ed. *Alabama Wildlife.* 4 vols. Tuscaloosa: University of Alabama Press, 2004.

Nash, Roderick. *Wilderness and the American Mind.* Rev. ed. New Haven: Yale University Press, 1973.

Nix, Steve. "Alabama Forest Inventory Completed." *Alabama's Treasured Forests* 20, no. 2 (Spring 2001).

Slaughter, Thomas P. *William Bartram: Travels and Other Writings.* New York: Library of America, 1996.

South, David E., and Edward R. Buckner. "The Decline of Southern Yellow Pine Timberland." *Journal of Forestry* (January/February 2003).

*The South's Fourth Forest: Alternatives for the Future.* Washington, D.C.: USDA Forest Service, 1987.

# INDEX

emergence, 7

Emerson, Ralph Waldo, 69

endangered species, 69

environment, 4, 26, 31, 33, 56, 62, 69, 71, 72, 77, 83, 84, 86, 89, 91; education, 83, 84; values, 56

environmentalists, 69, 83, 86

Eocene, 9

epoch, 10, 11

Erin Shale, 8

*Es:* three, 91

Escambia County, 49

ethics, 95

Europeans, 15, 20

evening primrose, 58

evergreen, 11, 17

exploitation, ix, 3, 7, 24, 26, 29

extinction, 9

fall color, 25, 47, 52

farms, 75

fences, 22

fern, 3, 58; Christmas, 11; lady, 58; resurrection, 93; wood, 58

fire, x, 3, 15, 22, 31

first forest, 33

fish, 9, 44, 59, 74, 79

fishing, 56

food chain, 42, 60

forbs, 58

forest: canopy, 43, 58; classroom, 64; clearing, 58; communities, 4, 8, 44, 48, 86; conservation, 86; controversy, 71, 77, 87; cover, 17, 26, 58, 72; diversity, 13, 38, 44, 48; habitat, 60; habitats, 48, 59, 60, 86;

health, 72, 86; heritage, 4, 73, 83, 91; industry, 49, 54, 55; management, 29, 31, 32, 33, 77, 86; marsh, 58; meadow, 58; owners, 75; policy, 72; recovery, 31, 33; regeneration, 31; resources, 4, 24, 72; stakeholders, 77, 81; types, 44, 45; understory, 43; values, 4, 54, 56, 62

forestland owners, 48, 74, 75, 81, 86, 91

forestlands, 3, 4, 15, 21, 22, 26, 31, 37, 48, 50, 56, 58, 59, 62, 64, 69, 72, 74, 75, 77, 79, 83, 86, 95, 98

Forests Forever Program, 83

Forever Wild Program, 50, 79, 83, 86, 87

Fort McClellan, 53

fossil, 7, 10, 11

fourth forest, 37

Fourth Forest Study, 37

fox, 59

Fred T. Stimpson Wildlife Sanctuary, 49

freedom, 26, 29

French explorers, 17

frogs, 60, 62

fungi, 62, 84

geologic time, 7, 9

geology, 44

giant horsetail, 8

global: change, 75, 77; water cycle, 58

goldenrod, 58

gopher tortoise, 59

Grand Bay Savannah pinelands, 53

grasses, 58

grasshoppers, 60

grasslands, 9, 13

Great Depression, 29

groundwater, 73

Gulf coast, 20, 40, 44, 53; sand dunes 70

gulf coastal region, 38

Gulf State Park, 50

Gulf States Paper Corporation, 50

Guntersville State Park, 41, 50, 60, 76

gymnosperms, 8

Hardtner, Henry, 29

hardwoods, 1, 10, 11, 17, 20, 37, 43, 44, 48, 50, 60, 71; forests, 10, 17, 43, 44, 48, 50, 71

Harper, Roland, 44, 101

health problems, 56

heartwood, 41

hemlock, 1, 11, 60

herbicides, 69

hickory, 1, 10, 20, 43

highlands, 20, 44

hikers, 73

holly, 1, 10, 43

Holocene, 9

hominids, 9

*Homo sapiens,* 11

honey, 25

Horseshoe Bend, 21

human population, 3, 72, 73, 83

hummingbird, 75

hunting, 14, 50, 56, 59, 62

Huntington College, 48

hydrology, 44

ice age, 9, 11, 13, 14

Indians, 15, 21, 26

Indian Removal Act, 21